# WORLD FILM LOCATIONS LOS ANGELES

Edited by Gabriel Solomons

First Published in the UK in 2011 by Intellect Books, The Mill, Parnall Road, Fishponds, Bristol, BS16 3JG, UK

First Published in the USA in 2011 by Intellect Books, The University of Chicago Press, 1427 E. 60th Street, Chicago, IL 60637, USA

Copyright ©2011 Intellect Ltd

Cover photo: MGM / The Kobal Collection

Copy Editor: Emma Rhys

Intern Support: George Murkin, Judith Pearson, Carly Spencer and Hannah Evans

A Catalogue record for this book is available from the British Library

**World Film Locations Series**
ISSN: 2045-9009
eISSN: 2045-9017

**World Film Locations Los Angeles**
ISBN: 978-1-84150-485-8
eISBN: 978-1-84150-533-6

Printed and bound by Bell & Bain Limited, Glasgow

# WORLD FILM LOCATIONS LOS ANGELES

**EDITOR**
Gabriel Solomons

**SERIES EDITOR & DESIGN**
Gabriel Solomons

**CONTRIBUTORS**
Nicola Balkind
David Owain Bates
Jez Conolly
Deirdre Devers
Michael S Duffy
Scott Jordan Harris
Wael Khairy
Toby King
Neil Mitchell
Michael Pigott
Isis Sadek
Jesse Schlotterbeck
Andrew Spicer
Benjamin Wiggins
Victoria Williams
Martin Zeller-Jacques

**LOCATION PHOTOGRAPHY**
Gabriel Solomons
(unless otherwise credited)

**LOCATION MAPS**
Joel Keightley

**PUBLISHED BY**
Intellect
The Mill, Parnall Road,
Fishponds, Bristol, BS16 3JG, UK
T: +44 (0) 117 9589910
F: +44 (0) 117 9589911
E: *info@intellectbooks.com*

Bookends: Hollywood sign (Gabriel Solomons)
This page: *Union Station* (Kobal)
Overleaf: *Somewhere* (Kobal)

## Maps/Scenes

## Essays

## ACKNOWLEDGEMENTS

Thanks must firstly go to my wonderful team of contributors who have been such a joy to work with and without whom this book would simply not exist. I would also like to thank the following people (in no particular order) for their invaluable help and support in putting together this book: Melissa Medel, Christian Gabriel Olguin, Alex, Gloria and Sofia Solomons, and my wife Helen Solomons who - along with my children - ensure I remain at least partially sane.

GABRIEL SOLOMONS

# INTRODUCTION

## *World Film Locations* Los Angeles

**CINEMA INEVITABLY** evokes a sense of place, and while films may be more about stories, the part that location plays in helping us to frame our understanding of the wider world is what this series of books aims to explore. Whether as an elaborate backdrop to a directorial love letter or as time specific cultural setting, the city acts as a vital character in helping to tell a story.

This particular volume of World Film Locations explores the sun-kissed, fractured, amorphous and thoroughly attractive city of Los Angeles. As one of the primary settings for the emerging film industry at the turn of the nineteenth century, Los Angeles has appeared in countless movies across every known genre, often depicting a city at odds with itself, battling with its own sense of identity in the midst of creeping urban sprawl and growing cultural fusion.

Hollywood may evoke a glamorous image in most minds but the city of Los Angeles on film weaves a far more complex tapestry of images and this is something that the content in this book looks to uncover.

As with other volumes in this series, we make no claim to be a completist's guide of film making in Los Angeles or an exhaustive listing of filming locations in the city. Rather this collection is an editorially driven journey of discovery that urges readers to begin looking at the 'city of angels' in a new light and perhaps even galvanize a few adventurous souls to use it as a handy filmic travel guide.

In this book you will find a selection of over 45 scene reviews from a variety of Los Angeles set films. These short synopses, written by a team of discerning film buffs present individual snapshots in time that often reflect a changing landscape of a city in flux. Locations such as Bunker Hill for example (as featured in Robert Aldrich's *Kiss Me Deadly*) have made way for a drastically different landscape as the Downtown regeneration plan of the 1950s made way for the high-rise cityscape we see today – and although many other locations featured remain unchanged, the way they have been used to convey place leaves an immediate and lasting impression of the city for those who may have only seen it 'in the movies'.

Alongside these scene reviews are a selection of spotlight essays that take a closer look at themes, directors or significant movements associated with Los Angeles onscreen, and which help to further reveal the incontrovertible symbiotic relationship between the city of Los Angeles and the film industry.

Taken as a whole, World Film Locations Los Angeles is a book that goes behind the scenes and onto the streets, resting at the crossroads where our imagination meets reality.

We hope you enjoy the ride. ✢

**Gabriel Solomons, Editor**

# LOS ANGELES

## City of the Imagination

Text by
MICHAEL
S DUFFY

**LOS ANGELES IS INDEED** a "city of the imagination," but in its population it has engendered feelings equally ambiguous and dogmatic. In cinema, as in life, it remains at odds with itself, its local cultures, and the portrayal of its landscape on screen. But Los Angeles has one thing that no other film location does – it is the creative and spiritual center of the Hollywood filmmaking industry. Since Thomas H. Ince established assembly line production and the first fully functioning studio in Culver City, Hollywood has been the place where mainstream American cinema is formed and fabricated, art is transformed into a commodity, and casting couches are broken in – and these days, given points on the gross.

Hollywood's "imagineering" has visualized Los Angeles as both the destination of dreams and a psychological dead end, Heavenly port (*City of Angels*, 1998) and a literal Hell on Earth (*Constantine*, 2005), and in studio backlot terms, "virtually" everything in-between. From science fiction conspiracy (*Blade Runner*, 1982) to contemporary urban menace (*Training Day*, 2001), Los Angeles continues to be utilized as a complex cinematic destina-

tion, with real-life locations made iconic through the imaginings of filmmakers. Just a few of the many local landmarks creatively captured by Hollywood cinema include Griffith Observatory (*Rebel Without a Cause*, 1955), the Vincent Thomas Bridge (*To Live and Die in L.A.*, 1985), and Zuma Beach (*Planet of the Apes*, 1968). In the early years of Hollywood, location shooting encouraged the development of silent slapstick comedy and gave the burgeoning local film industry a unique "claim" to the surrounding land. With widescreen technologies, landscape photography became an aesthetic and thematic counterpoint to the dense urban sprawl featured in many downtown L.A.-set films. The bustling backlots of studios like Paramount and MGM were occasionally featured on screen in variously successful attempts to comment on Hollywood's inside machinations (*The Bad and the Beautiful*, 1952). Lest we think that the industry was sustained entirely through falsified spectacle, the simple, uncomplicated location of the diner has never seemed as spacious or iconic as it is in the Los Angeles of *Pulp Fiction* (1994).

In the 1940s and 50s, film noir encouraged directors (many of them European immigrants) to artistically enhance their treatment of the Los Angeles landscape; the ambiguous angels of city life were given dirty faces through low-key lighting and ominous shadow-play. As David Bates notes in this volume, *The Big Sleep* (1946) – shot entirely on studio lots – is a "tribute to the L.A. of the imagination." *Kiss Me Deadly* (1955), considered by many to be the creative climax of first generation film noir, ends apocalyptically, and many L.A.-set films continue to harbor the underlying notion that Hollywood's dreams can ultimately end with the destruction of everything within, whether in

he is about *Manhattan* (1979), giving a lighter touch to the often dense and desolate material which populated American cinemas during the 1960s and 70s. Similarly, *L.A. Story* (1991) is one of the few contemporary portrayals of the city that manages to be both loving and satirical, while also avoiding the obvious trope of involving the film industry in its narrative.

Los Angeles and Hollywood continue to be at odds in form and function. 2011's *Battle: Los Angeles* reiterates Hollywood's fascination with appropriating more "gritty" material for its own purposes; the film replicates the visual and audio aesthetics of contemporary war epics like *Black Hawk Down* (2001) and the innovative science fiction of 2009's *District 9* in its hand-held narrative and fractured editing, but ultimately delivers familiar pleasures in an intense but frequently hollow blockbuster attitude. Analyzing Los Angeles as a "city of imagination," one usually finds it much more ambiguous, dense, and rich with complexity than most perceive. David Lynch's *Mulholland Drive* includes perhaps the most raw, revealingly sub-textual audition scene ever committed to a feature film, and his follow-up *Inland Empire* (2006) is truly apocalyptic, with a unique vision of Los Angeles and the psychology of contemporary filmmaking that dwarfs any other fiction or "reality." For *Los Angeles Plays Itself* (2003), filmmaker Thom Andersen masterfully combined aesthetic appreciation and cultural criticism in a nearly three-hour visual and audio treatise on how the industry both celebrates and misrepresents the city of Los Angeles on screen.

These days, it's acknowledged by industry veterans and scholars with a hint of irony that Los Angeles and its sound stages are known more for their ability to digitally replicate expensive locations such as New York City – yet Hollywood continues to struggle as a production entity, with steady competition (in the form of attractive tax rebates) from Canada, Eastern Europe, and the Australasian region. That the Los Angeles film industry has survived a century later amidst "runaway production" and blockbuster abandon is a testament not only to the industry's fortitude and rigorous business acumen, but its continually fascinating dark charms as both the city of angels and place of apocalyptic despair. ✢

physical or, more interestingly, psychological terms. *Sunset Boulevard* (1950) deconstructs the life of an aged actress desperate to hold onto her privileged existence, and reveals just how much hold Hollywood's "glamorous" life has over the rich and powerful – "boulevard of broken dreams," indeed.

Alternatively, film can perform an interesting archival function in movies like *The Exiles* (1961), which memorialized a number of Los Angeles-area locations and residential communities that were later razed for skyscrapers and stadiums. For relics of the past that do remain, cinematic Los Angeles seems to have the unique ability to bring to life stories from the past, future, and alternative dreamscapes. The barren banks of the Los Angeles River in *Sweet Sweetback's Baadasssss Song* (1971) helped usher in a contemporary cultural distinction and voice for black audiences, while in *Chinatown* (1974), water supplies and family corruption highlighted a neo-noir set in the 1930s, but never aging in lessons or meaning. Even an obscure genre sequel like *The Crow: City of Angels* (1996) has value, as the city's subcultures are played against each other in a dark physiological war of strikingly beautiful, artistically manipulated local iconography. On the bright side, Woody Allen manages to be as observant about Los Angeles in *Annie Hall* (1977) as

**Hollywood's "imagineering" has visualized Los Angeles as both the destination of dreams and a psychological dead end...**

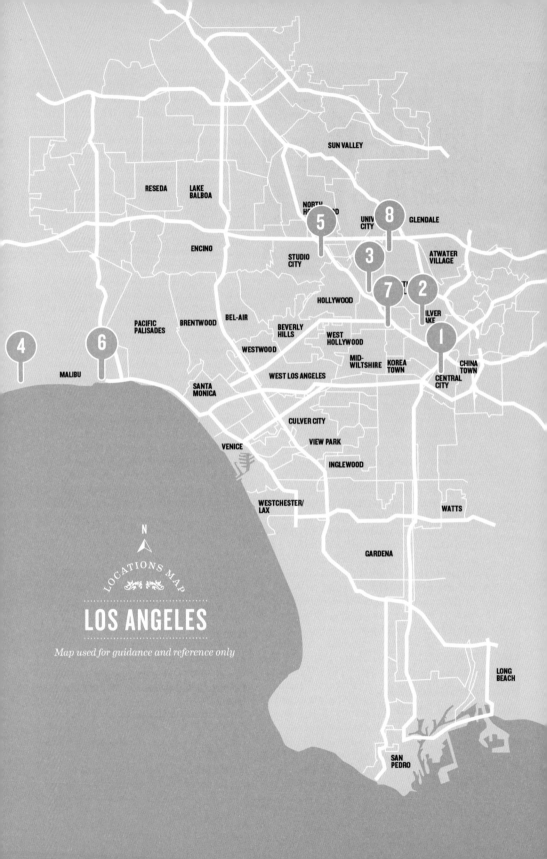

# LOS ANGELES LOCATIONS

## SCENES 1-8

# SAFETY LAST! (1923)

*The Walter P. Story building at 610 South Broadway, Downtown*

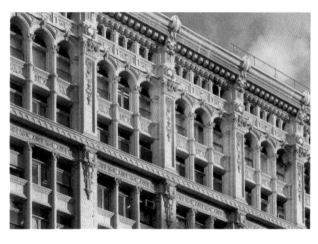

**LOS ANGELES** became home to silent comedians in the 1920s with its very own brand of comedy known as California Slapstick. Establishing himself as one of the greats, an innocent-looking chap named Harold Lloyd became the master of sky-high theatrics. Lloyd's greatest achievement is the classic *Safety Last!*, a time-honoured scene that reveals Los Angeles in all its glory from above. A dapper young man, awaiting his lady, is persuaded to climb one floor to escape a rowdy scene. Scaling the nearest pillar, he begins his ascent – the hard way. Clambering childishly, he arrives at the first floor embellishment overlooking Broadway and 9th. A reverse shot reveals a line of cars and passing trams, the beginnings of urban sprawl. Los Angeles landmarks cut horizontal lines into the urban backdrop. Masterfully delaying the inevitable, the striking heights of Broadway are resplendent in the sunshine. The key scene takes form as he dangles precariously from the face of a clock above Los Angeles' busiest intersection. Though LA architecture seems initially modest, through Lloyd's masterful suspense, the stunt, rather than boasting height, enlarges LA to proportions beyond film into the realm of iconography. Foregrounding the frantic scrambling of our hero, LA feels serene yet monumental; its rooftops a playground for the daring stuntmen of screen. Far from Coney Island antics and Keaton's coastal escapades, Lloyd made Los Angeles his moviemaking rec room, and brought the thrill of the chase to death-defying heights. **Nicola Balkind**

(Photos ©Martin J. Locke)

*Directed by Fred C. Newmeyer and Sam Taylor*
**Scene description: A frantic scramble up a Los Angeles skyscraper**
**Scene duration: 0:57:55 – 1:06:00**

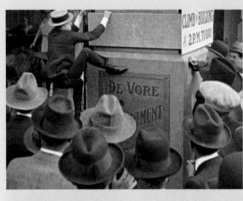 

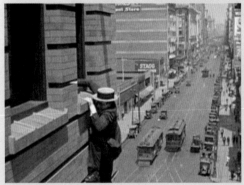 

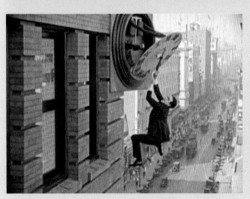 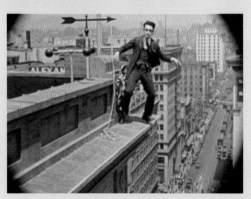

# THE MUSIC BOX (1932)

LOCATION *The steps between 923 and 935 Vendome Street, Silver Lake*

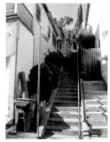

**THE STEPS BETWEEN** 923 and 935 Vendome Street in Silver Lake are the second most famous in film (or, at least, in films made before *Rocky* [Avildsen, 1976]). As much as any landmark has ever starred in a movie, they star in Laurel and Hardy's most acclaimed and iconic short, *The Music Box*. Only the Odessa Steps, as showcased in Eisenstein's *Battleship Potemkin* (1925), are better known – though I doubt they are better loved. Stan and Ollie's Sisyphean task is to carry a piano to the house at the steps' summit. In their first attempt they encounter an obstacle that further unites them with (and perhaps references) Eisenstein's Odessa Steps sequence: a mother pushing a baby in a pram. She asks them to let her pass and, as they try to accommodate her, they let go of the piano. In a shot so perfect and improbable it is like live action animation, the piano slides down the steps with film's funniest duo sprinting after it. The scene showcases much of that at which Laurel and Hardy excel: the comedy switches from subtle to broad in a second, as does their desire to help their fellow man and to kick him (or her) up the backside. But the scene's greatest impact is delayed: it foreshadows the scene in which, told they need not have carried the piano to the top of the steps but could have driven up by another road, Stan and Ollie carry it back down so they can do just that. ➻***Scott Jordan Harris***

*Directed by James Parrott*
**Scene description: 'Would You Gentlemen Please Let Me Pass?'**
**Timecode for scene: 0:03:21 – 0:05:50**

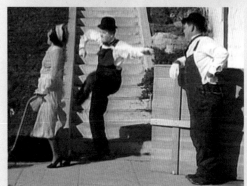 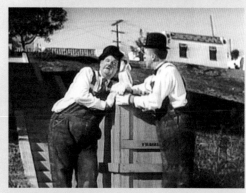

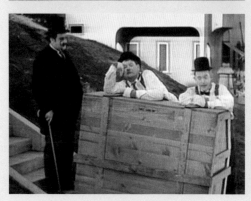 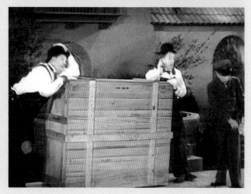

Images ©1932 Hal Roach Studios

13

# DOUBLE INDEMNITY (1944)

LOCATION *Dietrichson House, 6301 Quebec Drive, Hollywood Hills*

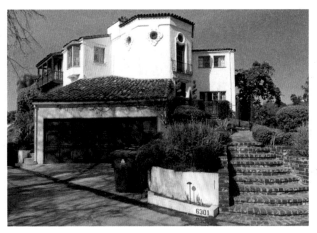
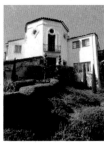

*'It was one of those California Spanish houses everyone was nuts about ten or fifteen years ago. This one must have cost somebody about 30,000 bucks – that is, if he ever finished paying for it.' – Walter Neff*

**WALTER NEFF'S** (Fred MacMurray) entrapment by femme fatale Phyllis Dietrichson (Barbara Stanwick) in Wilder's noir classic begins with his arrival at the Dietrichson house; an exclusive, imposing mansion in the Hollywood Hills. The house is a signifier of urban alienation and dehumanization – isolated, unwelcoming – and inside Phyllis waits for her prey to become ensnared like a spider commanding her web. Behind the palms, the building's high walls suggest the occupant has something to hide, and that once inside and inculcated in Dietrichson's insidious scheme to inherit her husband's wealth, Neff in some ways never escapes. Portents of imprisonment abound inside the house: the bars of the wrought iron staircase that Dietrichson sweeps down to greet Neff that first time; the ball-and-chain of her anklet that we see in close-up; the light filtering through the venetian blinds. In every sense Neff is a dead man walking (and talking – his confessional Dictaphone recording is the narrative's framing device) and the Dietrichson house is as much a mausoleum as it is a jailhouse. Its dusty funereal interiors imply a state of death and decay, and wherever else we see Neff during the film, be it the drab aisles of a supermarket or the empty lanes of a bowling alley, somehow he is still stuck on Death Row. **Jez Conolly**

*Directed by Billy Wilder*
*Scene description: Walter Neff arriving at the Dietrichson house for the first time*
*Timecode for scene: 0:06:55 – 0:07:15*

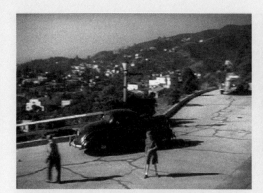 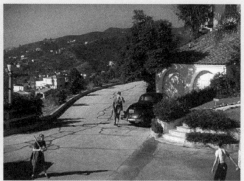

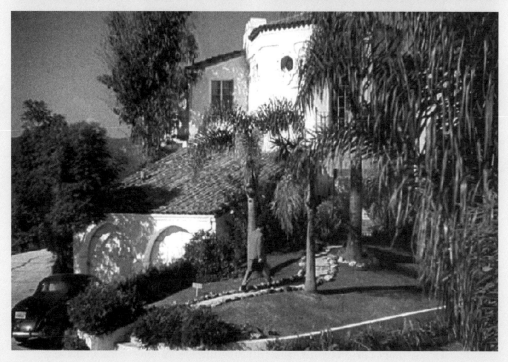

# MILDRED PIERCE (1945)

*26652 Latigo Shore, Malibu*

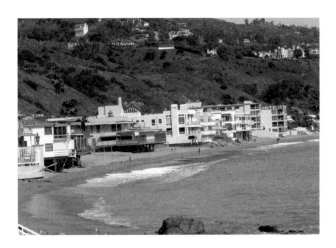

**LABELLED AS 'BOX OFFICE POISON'**, Joan Crawford was let go by MGM's Louis B. Mayer who was convinced that her star had faded. Crawford went to Warner Brothers and took the part of Mildred Pierce, a role that had even been turned down by Crawford's arch enemy, Bette Davis. Based on James M. Cain's novel, Michael Curtiz's *Mildred Pierce* earned Crawford an Oscar. One of the best examples of film noir, the rich black-and-white highlights Crawford's distinctive face perfectly as she plays the title character struggling to keep her family together after her philandering husband leaves. With the help of a playboy financial backer, Monte Beragon (Zachary Scott), she goes from waitress to restaurant owner. Malibu then, as now, is a scenic, exclusive enclave for the wealthy. It's where Mildred goes to put her business plan to Monte and it's where the film's opening murder takes place. Malibu is the 27 mile strip of prime sandy beach coastline along the Pacific. The exterior for Monte's home where he was murdered actually belonged to Curtiz. Located on Latigo Shore, the house was built in 1929 when Malibu was known as Malibu Colony, but it collapsed into the ocean in 1983. Seven years later, Malibu was incorporated into a city. Curtiz, recognizing that Malibu represented a place and lifestyle to which many aspire, cleverly uses the locale to demonstrate that the road to affluence can have a steep price.
**•◦Deirdre Devers**

**Above** Townhomes lining the beach on Latigo Shore Drive

*Directed by Michael Curtiz*
**Scene description:** *Murder of Monte the investor in Malibu*
**Timecode for scene:** *0:01:36 – 0:02:06*

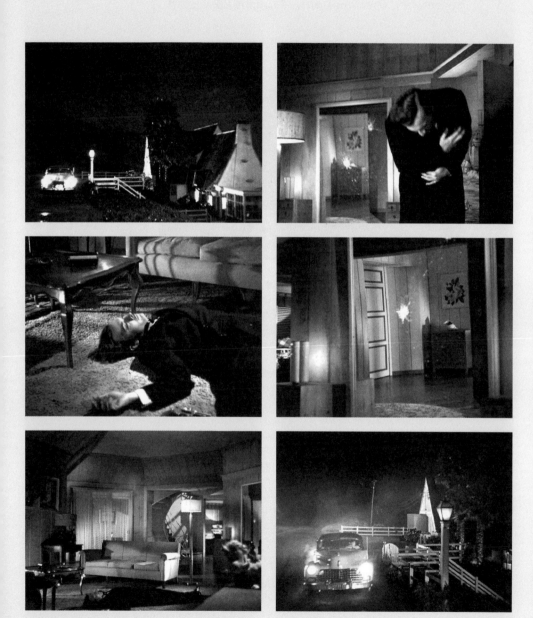

# THE BIG SLEEP (1946)

LOCATION

*Laverne Terrace, a fictional location created on a studio lot to represent a street on Laurel Canyon Boulevard*

**THE BIG SLEEP** was shot entirely on studio lots in a city that offered a plethora of real locations. Geiger's house is the fictional Laverne Terrace, which, according to the book, is near Laurel Canyon in the Hollywood Hills. An abundance of architectural styles proliferated there, often pastiching one style or another. Geiger's house has rustic pretensions, with stone walls and wooden shutters. Marlowe (Humphrey Bogart) is alerted to trouble within by a flash in the window and a scream, followed seconds later by the sound of gunshots; an aural disconnect to the flash adding to the overall artifice of the scene. Inside, the set designers provide an abundance of oriental exoticism at odds with the exterior and with Marlowe's sombre attire. He discovers a drugged Blanche standing over Geiger's dead body. The interior is bedecked with drapes, textiles and beads with a Far East theme. Blanche herself is wearing a kimono with a dragon motif; the whole effect is one of treachery and corruption in a film made when the USA was fighting the Japanese. Marlowe finds a hidden camera, the source of the flash, and the intimation is of intrigue, blackmail and double dealing – even Marlowe duplicitously covers the tracks of his rich client's daughter. The house is used in other pivotal scenes, as various sleights of hand are played out, including a disappearing and reappearing corpse. The establishing scene is a tribute to the LA of the imagination, where all things are possible with the craft of Hollywood set designers. **➠David Bates**

**Above** West Mulholland Drive / Laurel Canyon Boulevard (Photos ©Neil Hopper)

*Directed by Howard Hawks*
**Scene description:** *Marlowe discovers Carmen, high on drugs, with Geiger's body*
*Timecode for scene: 0:20:08 – 0:24:13*

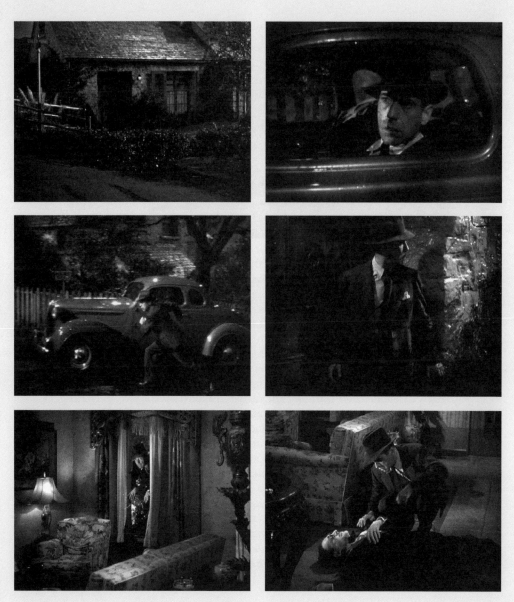

Images ©1946 Warner Bros

# THE BLUE DAHLIA (1946)

*Royal Beach Inn (fictional hotel), south of Malibu*

**GEORGE MARSHALL'S** *The Blue Dahlia* is one of the most recognisable film noirs. Written by Raymond Chandler, it follows Johnny Morrison (Alan Ladd), an ex-bomber pilot suspected of murdering his wife, Helen (Doris Dowling), in the Blue Dahlia nightclub. On the run, he meets the beautiful Joyce Harwood (Veronica Lake) who, unbeknownst to him, is the estranged wife of the nightclub's owner, Eddie Harwood (Howard Da Silva). En route to Malibu through the deluge of Los Angeles rain, Joyce offers Johnny a lift. More than a metaphorical use of weather, the downpour magnifies the irregularity of finding a lone figure walking in the wet urban sprawl. Despite their mutual connection to Harwood, the two are strangers, heightening the feeling of coincidence. Pushing against this, Johnny takes his leave at the first possible moment. In the Royal Beach Inn dining room south of Malibu, Johnny takes a seat for brunch in front of a gorgeous coastal vista – the California weather clear after the rain. Catching a glimpse of him in her compact's mirror, Joyce joins him, perching on the white brick wall as waves crash behind them. A distinctive rock stands rugged in the water; a crater in its side concealing inner depths. Having escaped the heavy rain and drama in Los Angeles, they share a moment of confidence, conceding that they must return north. Having reached the 'end of the line' in the form of the coast, Johnny ditches Joyce once again. Like Los Angeles, he cannot escape her; they are bound in ways that cannot be seen. ➙ *Nicola Balkind*

**Above** View towards the East of Los Angeles from Malibu Beach

*Directed by George Marshall*
Scene description: Johnny and Joyce talk in an ocean-side hotel restaurant
Timecode for scene: 0:33:42 - 0:36:16

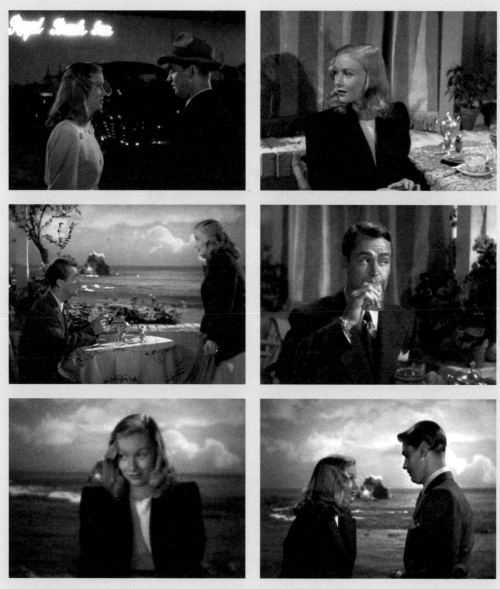

Images ©1946 Paramount

# SUNSET BOULEVARD (1950)

*Paramount Studios at 5555 Melrose Avenue, Hollywood*

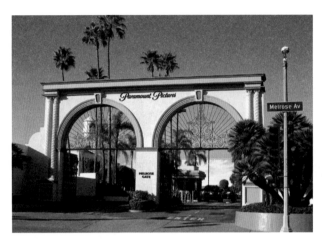

**ANTHROPOLOGIST** Hortense Powdermaker wrote of Hollywood as the 'dream factory', and Los Angeles' Sunset Boulevard has long been described as the boulevard of broken dreams. For Wilder, Sunset Boulevard remains the street where dreams are derailed, curtailed, stalled or turn to delusions. Wilder's cautionary tale of life in Hollywood concerns down-on-his-luck screenwriter Joe Gillis (William Holden), who inadvertently becomes involved with forgotten silent film actress Norma Desmond (Gloria Swanson). In dire need of cash, he develops a script according to Desmond's demands only to become complicit with becoming Desmond's well-kept lover. Ignoring repeated phone calls from a Paramount executive, Desmond is flummoxed that producer/director Cecil B. DeMille has not phoned her personally regarding the script. With Joe at her side and her servant (Erich von Stroheim) at the wheel of her handmade car, they drive to Paramount's famous gates at 5555 Melrose Avenue. Once inside, Wilder not only gives the audience a tour into the Paramount dream factory by enlisting a cameo from DeMille himself as he directs *Samson and Delilah* on Stage 18, but also an insight into the *business* of show-business – the false smiles and threadbare adoration that operate to keep Desmond a star only in her own mind. Paramount, situated on a street parallel to Sunset Boulevard, is the only major film studio still in Hollywood. Established in 1913, Paramount, for Wilder, symbolises the shimmering Janus-faced dream-maker (and breaker) that continues to beckon. **➥Deirdre Devers**

*Directed by Billy Wilder*
*Scene description: Norma Desmond returns to Paramount*
*Timecode for scene: 1:02:01 – 1:12:34*

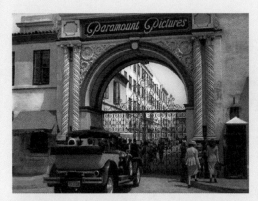 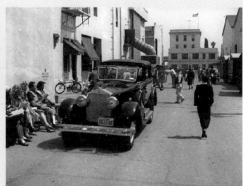

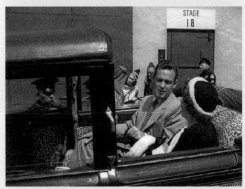 

# REBEL WITHOUT A CAUSE (1955)

LOCATION *Griffith Park Observatory, Griffith Park, Mount Hollywood*

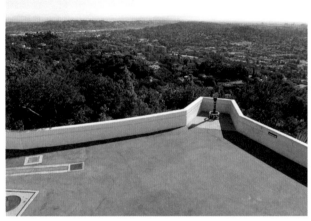

JAMES
DEAN

**BEFORE THE FINGER-CLICKING** and toe-tapping of NYC's *West Side Story* (Robbins and Wise, 1961), there was a *Rebel Without a Cause* on the mean streets of Los Angeles. Nicholas Ray's seminal film starred Hollywood legend James Dean in his definitive role as Jim Stark – hitting cinemas only a month after the star's fatal car crash. On a field trip to Griffith Observatory in the foothills of Los Angeles, class bully Buzz (Corey Allen) and his girlfriend Judy (Natalie Wood) launch a high school style crusade on the new kid in town (Dean). Taunting him by slashing the tyres of his car, he invites Stark to a knife fight. The long sequence takes place at the park's walled edge, overlooking the urban sprawl of North Hollywood. As Stark resists, the scene escalates, the sprawl beyond the walls becoming wider and more threatening. High angle shots widen the depth of field and the eerie sensation of escalating danger. Though the Observatory surveys the stars, we observe the fight from high angles as they jab and flinch. Buzz's high-pitched giggling offsets the dramatic string score as he uses a look-out point telescope to distract Stark, all the while reinforcing our acute awareness of what lies beyond those waist-high walls. A characteristic LA smog hangs above the city, recognisably thick and oppressive, muddying the horizon to create a feeling of entrapment. For the *pièce de résistance*, Buzz's coiffed head is pressed against the wall, knife to his neck, a vista of forest littered with Mission-style homes stretching out beneath him. The resistant ruffian has won, making a name for himself in Los Angeles' subculture of teenaged rebels. **➡Nicola Balkind**

*Directed by Nicholas Ray*
*Scene description: Jim and Buzz knife fight*
*Timecode for scene: 0:33:22 – 0:36:11*

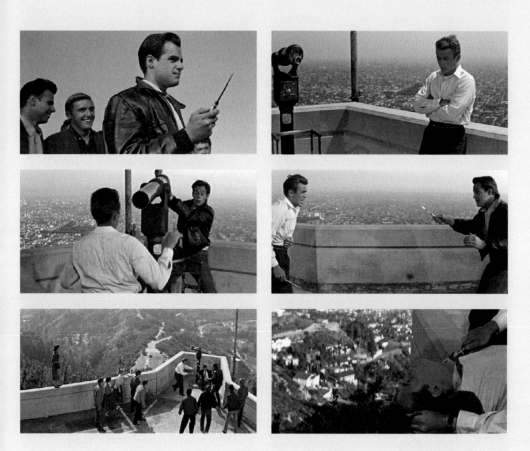

# CALIFORNIA SLAPSTICK

Text by
NICOLA
BALKIND

*On Location Film-Making Gets Rolling*

**LOS ANGELES EXPERIENCED** a boom of moviemaking activity in the 1910s and 1920s, making itself home to silent comedians. Film scholars celebrate this period – a golden age – and its unique brand of comedy known as 'California Slapstick'. Among the greats, Charlie Chaplin made a name for himself as The Little Tramp, Buster Keaton earned his nickname The Great Stone Face, and an innocent-looking chap named Harold Lloyd became the master of sky-high theatrics. The trio are now known as The Silent Clowns, an all-encompassing term that marks them as one of film history's most elite director-performers: the masters of silent comedy.

The earliest silent comedies, including work from Roscoe 'Fatty' Arbuckle, are best associated with New York. Early film stars like Arbuckle, Mable Normand and Buster Keaton's first shorts were shot on the East Coast, making use of iconic locations such as Coney Island to excellent comedic effect. However, the lack of light in winter meant that film-making had to shut down for several months out of the year. In 1907, Chicago's Selic

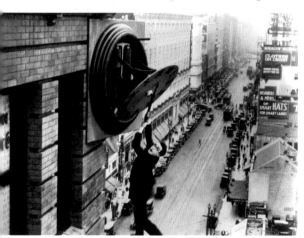

Polyscope Company relocated to Edendale, California, an area which now encompasses much of modern Los Angeles' Echo Park and Silver Lake. The move sparked a number of followers, and in 1913 Mack Sennett's Keystone Company found a new home for his infamous Keystone Kops in Edendale, close to Echo Park Lake. The move to California provided year-round sunshine essential to on-location shooting, along with the stunning locations themselves. In short, Los Angeles was the studio of every 19-teens film-maker's dreams. Sennett's Keystone was a training ground for silent film comics, with all three comedy masters cutting their teeth on the Edendale lot alongside W.C. Fields, Ford Sterling, Marie Dressler and Harry Langdon.

While all three masters hopped from studio to studio and two-reelers paved the way to feature films, their locations largely remained in Los Angeles well into the 1920s. Each has a film whose use of location is a stunning testament to LA film-making and the undeniable brilliance of California Slapstick. Charlie Chaplin takes to the streets (and the ocean) in *A Day's Pleasure* (Chaplin, 1919); Buster Keaton literally builds himself a home in *One Week* (Cline and Keaton, 1920); and Harold Lloyd's *Safety Last!* (Newmeyer and Taylor, 1923) finds him dangling above Los Angeles.

*A Day's Pleasure* was shot at Chaplin Studios, Hollywood. Chaplin's office appears on the corner during the first scene, where the Tramp, along with his wife and two children, hop into the car for a day out (which predictably goes awry). Los Angeles' iconic San Gabriel Mountains jut into the sky in the distance, employing the size and stillness of the mountains as a backdrop. Chaplin's location provides an incongruous element for his tiny figure to work against, serving to exaggerate the comical bounce of the little fellow's crank-

started car. The audience become privileged viewers of this queer little slice of life – a play on the idea of keeping up with the Joneses, which was prevalent in 'teen Hollywood. Chaplin's inventiveness with space is never banal in reference to the use of his own body.

Chaplin also re-uses a gag from *The Immigrant* (1917), in which he is on board a rocking boat. In keeping with his location, the houseboat see-saws, but – unlike the immigrant ship to New York – the California coastline acts as an anchor to make the swaying motion more pronounced, and the constant in-out of a trombone takes this further still. Los Angeles' locale sets the foundation upon which Chaplin tops the gag, before something outside himself tops it again and again. Just as the city is built, gags are built upon the city.

Buster Keaton builds upon the city in a more literal way in *One Week* (Cline and Keaton, 1920). A pair of newly weds – he and his wife – find their plot of land and set about building their first home. A villainous ex-boyfriend seeks his revenge by modifying the numbers on the building blocks, which results in a chaotic set of rooms that create a haphazard home that only Buster Keaton could have

dreamt up. What he builds upon is a square unfurnished lot, surrounded only by identical plots of land and a train track. To the untrained eye, they could be anywhere in Midwest America. When they discover that they are inhabiting the wrong plot, they simply attempt to move the house to the correct piece of land. Rolling the home on barrels, attaching it to a car, and – after several failed attempts – leaving it in ruins, the location could be replaced with flat land in any other state. What the palm trees in the distance remind us, though, is that this unmarred soil is the last great American bounty. Home is where you park it, and as long as the couple are together, Los Angeles will be their home.

A mere three years later, Harold Lloyd's Los Angeles is a sky-high metropolis. Far from constructing a building of his own, he instead tests the limits of its existing structures by placing himself upon their towering heights, bringing a new sensory experience of Los Angeles to film. Rather than making himself the fly on the scaffold, Lloyd's focal point is the delay of the ultra-inevitable. Making a show of his clamber to the first floor, he makes a quick descent to break the tension. Beginning again, the aim is to extend the inevitability of the gag to its furthest tension point. As he crouches on ledges and hangs from a clock-face, Los Angeles lingers below. The rush of the city continues; beetle-like trams scuttling along their tracks and miniscule people going about their business as he dangles freely above the city. Flat-topped buildings cut horizontal lines into the urban backdrop to emphasise height, contrasting Lloyd's dapper figure with the unmoving background; small but significant.

Los Angeles marked a crucial change in film-making techniques for slapstick comedy. The various stages of development throughout the city allowed them to shoot close-up or far away from the city, country and coast. The great outdoors was at their disposal, modified or *au naturale*, making it perfect for the genre's hallmark: the chase. Los Angeles also gave the genre room to grow, allowing these auteurs to move out of conventional modes and into their own unique styles of film-making and performance. Though born back east, California Slapstick found its voice, and its name, in old LA. ✣

> **Los Angeles marked a crucial change in film-making techniques for slapstick comedy. The various stages of development throughout the city allowed them to shoot close-up or far away from the city, country and coast.**

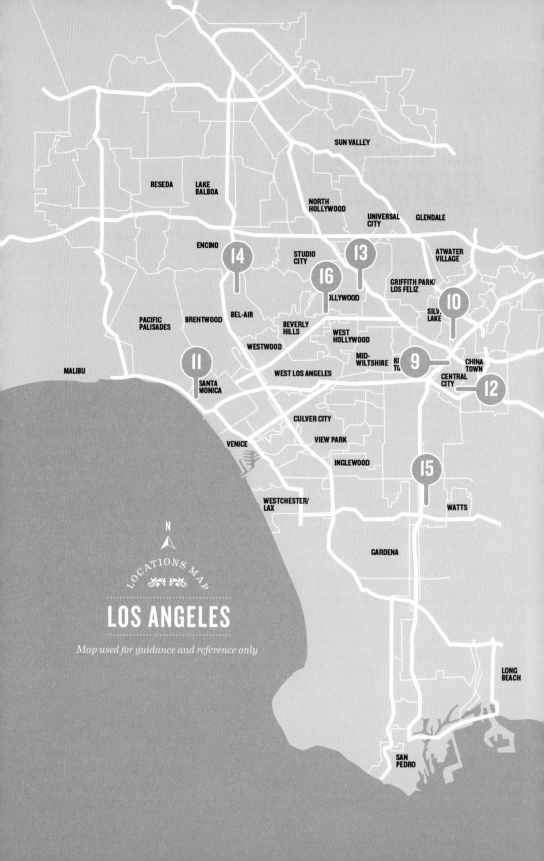

# LOS ANGELES LOCATIONS

## SCENES 9-16

# KISS ME DEADLY (1955)

*Angels Flight Railway, 351 South Hill Street, Downtown*

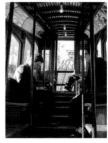

**ABOUT AN HOUR** in to Robert Aldrich's Cold War noir/pulp classic *Kiss Me Deadly* there is a brief appearance by 'Olivet' and 'Sinai', the two cars that ploughed up and down Angels Flight funicular railway in the Bunker Hill area of LA from the time of its construction in 1901. With just 298 feet of track it became known as 'the shortest railway in the world'. When the railway was first pressed into service Bunker Hill was one of the city's more fashionable neighbourhoods; but by the time Aldrich came to film there the once grand houses of the area's wealthy elite had been reduced to a semi-dereliction of dosshouses – the perfect setting then for private eye Mike Hammer's (Ralph Meeker) seedy investigations into the underworld. Hammer is headed for the Hillcrest Hotel where, in typical Mickey Spillane style, he's about to force information out of a second-rate tenor by smashing his rare recording of Caruso's *Pagliacci*. We see Hammer drive underneath the tracks, timed perfectly so that the two rail cars cross above him; a shot that illustrates Hammer's ability to worm his way under the surface of the city in his attempts to reveal the facts beneath the façade of the case he is pursuing. Despite the area's continued decay, the Angels Flight railway continued to operate until 1969, when it was eventually dismantled. However, 'Olivet' and 'Sinai' returned in the mid-1990s when the track was erected once more, half a block south, adjacent to the California Plaza. ➻ *Jez Conolly*

*Directed by Robert Aldrich*
Scene description: *Mike Hammer drives underneath Angel's Flight funicular tracks*
Timecode for scene: *0:53:35 – 0:54:18*

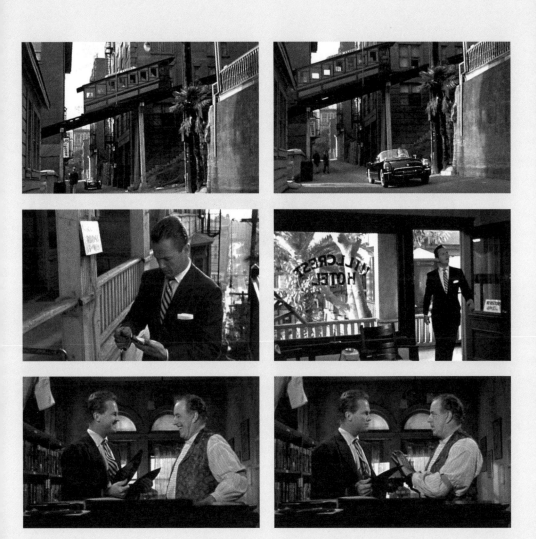

# THE EXILES (1961)

*"Hill X", now Dodger Stadium, 1,000 Elysian Park Avenue*

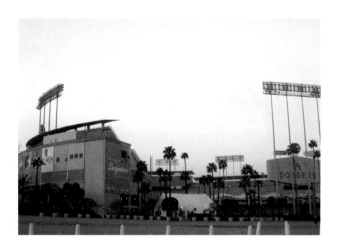

**ONLY RECENTLY RESTORED**, Kent MacKenzie's dramatized documentary *The Exiles* was shot over three years in the Bunker Hill of the late 1950s, shortly before the residential area's redevelopment created the now familiar landscape of Downtown skyscrapers. Using evocative black-and-white cinematography, *The Exiles* chronicles twelve hours in the lives of Native Americans Yvonne and her boyfriend Homer, beautifully documenting these outsiders' experience of the city. Pregnant Yvonne walks through Grand Central Market, takes in a movie, window shops, and reflects with satisfaction at having moved to Los Angeles while speaking hopefully of her baby's future. Homer spends the evening drinking and socializing with friends in bars on Broadway and Grand Street. Throughout, Homer is more of an observer than a participant. His thoughts, heard in voice-over, reveal the men's uneasiness with the lack of opportunities available to them in the city. This is why Hill X has a special meaning for Homer and all those who congregate there nightly after closing time. Though the hill and the surrounding residential communities of Chavez Ravine would be razed to make way for Dodger Stadium (home to the city's baseball team) even before *The Exiles* was completed, it is a place of freedom for Homer and his friends. There they dance to tribal drumming and chanting, a million miles from the Downtown bars' rock, doo-wop and conga rhythms. Overlooking the city, these Native American men and women engage in frenzied dancing, argue, fight and fall asleep on the unkempt hill. On the fringes of LA, this place reminds Homer of home, of people he hasn't seen for far too long and of good times. **Isis Sadek**

*Directed by Kent MacKenzie*
**Scene description: Homer and his buddies let loose on Hill X**
**Timecode for scene: 1:03:06 – 1:10:05**

Images ©1961 Kent MacKenzie

# POINT BLANK (1967)

*The Huntley Hotel, 1111 2nd Street, Santa Monica*

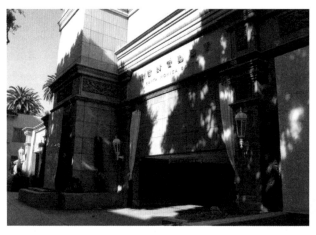

**THE HUNTLEY HOTEL** in Santa Monica still stands today, largely unchanged from 1967 when it appears in a pivotal scene in John Boorman's *Point Blank*. The hotel belongs to, and is used as a safe house by, 'The Organization', which here represents the corporate capitalism of mid-twentieth century America; a thoroughly home-grown crime family. Walker, played by Lee Marvin, has been betrayed by a friend who uses the money they stole together in a robbery (in which Walker was left for dead) to buy his way back into The Organization. Walker wants his share of the cash – $93,000 – returned and doesn't care if it is his double-crossing ex-friend Reese (John Vernon) who pays him or his bosses, as long as he gets paid; business is business after all. Reese is ensconced in a penthouse suite at the hotel (with all the gilded connotations of the '60s playboy aspiration this setting represents); the prodigal son returned to the fold. Through misdirection and icy nerve Walker gains entrance to this heavily-guarded location to confront Reese, fully aware that this is a trap. In the ensuing struggle Reese plunges to his death, himself having been set up by The Organization as bait for Walker. Walker calmly exits the hotel the way he entered – through the basement car-park. Interestingly the Huntley is referred to by name in the movie and mentioned as being owned by the criminal group; could we expect this (would this be the case) in today's more public relations aware world? ➺ *David Bates*

*Directed by John Boorman*
**Scene description: Walker ambushes Reese in his heavily guarded penthouse**
**Timecode for scene: 0:48:55 – 0:53:00**

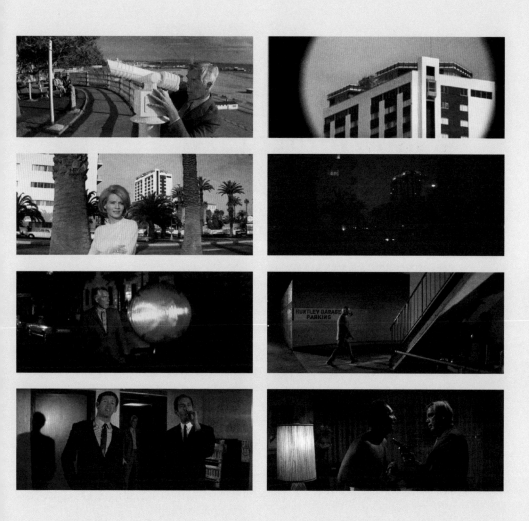

# SWEET SWEETBACK'S BAADASSSSS SONG (1971)

*Los Angeles River at 7th Street*

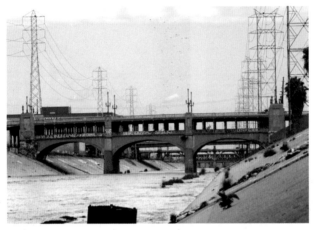

**WHEN COLUMBIA DECLINED** his demand for a minority crew and a flexible script, Melvin Van Peebles 'was determined not to do another film with a Hollywood producer riding my back.' *Sweet Sweetback's Baadasssss Song* was the result. Possessing creative control but lacking studio resources, Van Peebles – a self-proclaimed guerilla film-maker – shot entirely on location while ducking both police and union officers. Witness to police brutality, Sweetback (Van Peebles) defends a young black revolutionary and is hunted by the cops for the remainder of the film. Van Peebles stages his escape in the forgotten spaces of South Los Angeles such as construction sites, grasshopper pump fields, dead-end roads and dry basins. Sweetback's exodus may appear haphazard, but one landmark guides him: the railroad. As Sweetback begins his journey through the concrete banks of the Los Angeles River, the camera zooms out and pans over to the tracks that run with the waterway. In the film's unique shooting script, Van Peebles compares Sweetback's route to that of early pilots who would navigate their flights from Sacramento to Ensenada using the railways as their compass. Midway through production, LAPD officers pulled over Van Peebles' multiracial second-unit crew because they mistook their telephoto lens for a bazooka. Despite presenting the proper papers, the police detained the crew members. But neither real-world cops nor those in the film bring down Van Peebles. On the twentieth and final day of his perilous shoot, the director, exhausted as his character, filmed Sweetback following the rusted rails to freedom. •*Benjamin Wiggins*

**Above** Southward view of 7th Street Bridge from beneath the 6th Street Bridge (©Kimbrough Photography)

*Directed by Melvin Van Peebles*
*Scene description: Sweetback's exodus from Los Angeles*
*Timecode for scene: 1:01:21 – 1:15:20*

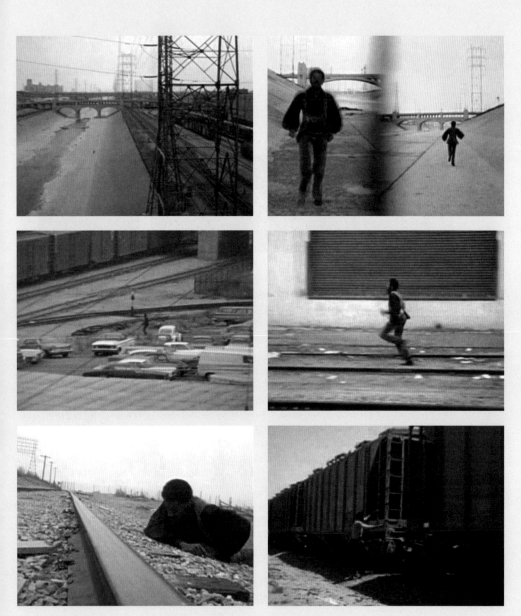

Images ©1971 YEAH

# THE LONG GOODBYE (1973)

LOCATION *High Tower, 2178 High Tower Drive, Hollywood*

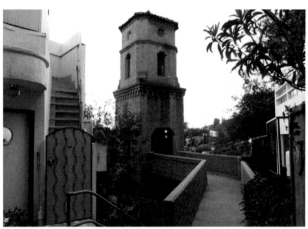

**LIKE MARLOWE** (Elliott Gould) himself, the High Tower is a relic from another time. Built in the 1930s, it belongs in a film noir. But in Altman's film even this bastion of old LA elegance has been penetrated by the ideals and lifestyles of a newly health-conscious, self-involved and materialistic Los Angeles – Marlowe's next-door neighbours on the other side of the strange, imposing tower of the outdoor elevator are a troupe of naked, yoga-performing, pot-cookie-consuming young women. His only real friend is his cat, and even the cat is using him for Coury brand cat food. This odd, free-standing elevator in North Hollywood was modelled after a Bolognese *campanile* (or bell tower), and originally allowed access to an enclosed and street-less artist's community. In a city famous for its cars, this was a place where you had to walk. This touch of idiosyncrasy suits Marlowe, a detective from another time. However, the very characteristics that make Marlowe anachronistic also make him a subversive figure. His ragged appearance, constant mumbling and way of meeting a world full of weirdness, cruelty and betrayal with stubborn amusement mark him as an eccentric; a denizen of the counter-culture, at odds with the world around him, just as the High Tower is. Through Marlowe's wide bay window we see both welcome and unwelcome visitors approaching along the concrete walkway from the elevator; we see the hi-jinks on the girls' balcony; and at night we can even spy the twinkling light haze of Hollywood Boulevard. **↔ Michael Pigott**

(Photos ©Noah Albert)

*Directed by Robert Altman*
**Scene description: 'Hi girls. You seen my cat?'**
*Timecode for scene: 1:38:41 – 1:39:27*

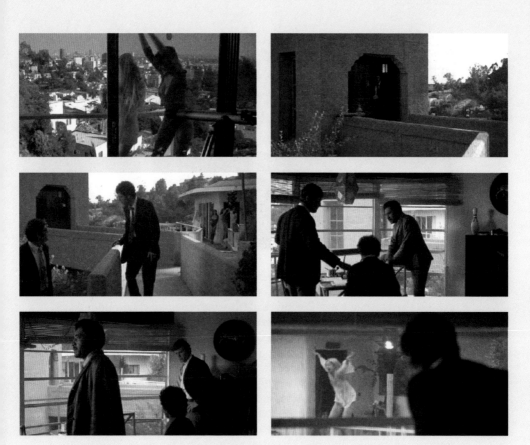

# CHINATOWN (1974)

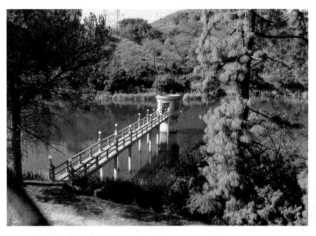

**ROMAN POLANSKI'S** classic Neo-Noir is a veritable tour of Los Angeles landmarks. Capturing the hidden sacrifices and backroom dealings behind the emergence of LA as one of the world's great cities, *Chinatown* revels equally in Los Angeles' classic Spanish Colonial architecture, the glamour of iconic Hollywood restaurants like The Brown Derby (represented in the film by The Prince, in Koreatown), and the urban backwash of the city's aqueducts, bridges and barren riverbeds. The more Gittes (Jack Nicholson) uncovers of the conspiracy to steal water from the city, the more we see the squalor behind LA's veneer of sophistication and charm. The first glimpse beneath the surface comes when Gittes visits the Oak Pass reservoir, looking for the chief engineer of the Water and Power company, Hollis Mulwray. Already suspicious that someone is trying to hurt Mulwray, Gittes' is proved right when he finds the reservoir crawling with police. The location unites the bleakness of the desert, which the film portrays as always just outside the city, waiting to reclaim Los Angeles, and the progress and civilisation represented by man-made waterworks. Here, we have left behind the sleek urban streets and marble buildings where Gittes is most comfortable, and as the scene ends, he is confronted with Mulwray's corpse, being dragged up a runoff channel by a pair of firemen. For the first of many times, JJ Gittes finds himself in a situation with more layers than he can comprehend. **•› Martin Zeller-Jacques**

*Directed by Roman Polanski*
**Scene description: Meet Mr. Mulwray**
**Timecode for scene: 0:29:33 – 0:32:02**

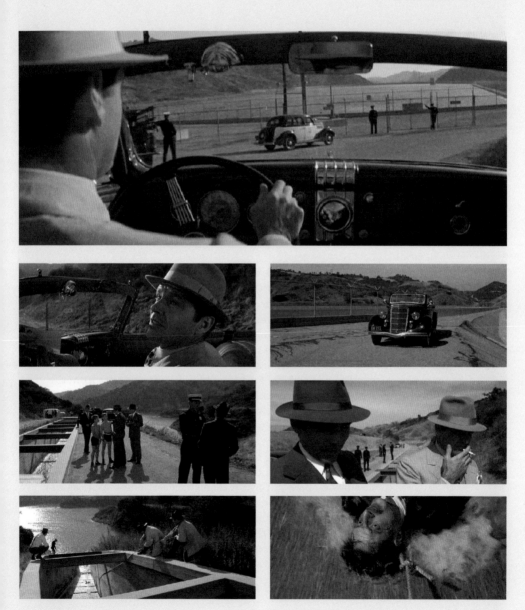

Images ©1974 Paramount

# KILLER OF SHEEP (1977)

*East 99th Street and Towne Avenue, Watts*

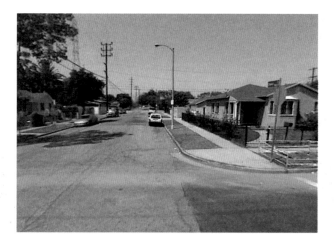

**CHARLES BURNETT'S** black-and-white film *Killer of Sheep* was his UCLA thesis film made for $10,000 over a series of weekends in 1973. The poetic black-and-white film is a hauntingly beautiful snapshot of life in the poverty-stricken Watts neighbourhood of South Central Los Angeles. Though the film is composed of a series of vignettes, the focus is on Stan (Henry Gayle Sanders) and his family. Unlike most of his friends, Stan has a job doing mind-numbing work. He is anxious, exhausted and yearns to provide a better life for his family. All around him are children playing on train tracks and people on the hustle, punctuated by threats or violence. One such vignette sees a gaggle of youth sitting idly on a fence as mute witnesses watching two thieves brazenly steal a large TV. Burnett filmed the scene in an alley at East 99th Street and Towne Avenue around the corner from where he lived. Watts became a predominantly black neighbourhood during the 1940s as thousands left the segregated South in search of better opportunities. The area, however, gained national prominence during the six-day-long Watts Riots in 1965 that many viewed as a reaction to the widespread injustices that blacks suffered. *Killer of Sheep*, filmed eight years after the Watts Riots, is a sensitive and humanistic portrait of the day-to-day life of people getting by in the ways that they know how. **⟿Deirdre Devers**

**Above** Corner of East 99th Street and Towne Avenue

*Directed by Charles Burnett*
*Scene description: Neighbourhood youth watch the theft of a TV*
*Timecode for scene: 0:06:35 – 0:08:05*

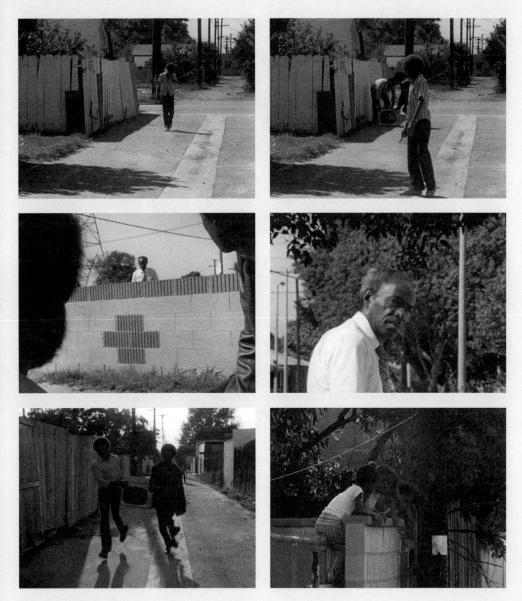

Images ©1977 Milestone Films

# ANNIE HALL (1977)

LOCATION *Source Restaurant, 8301 Sunset Boulevard, West Hollywood*

**'I'M GONNA HAVE THE ALFALFA SPROUTS** and a plate of mashed yeast.' Neurotic New York stand-up comedian Alvy Singer (Allen) finds himself to be a total fish out of water when he arrives in Los Angeles in a last-ditch attempt to win over Annie (Diane Keaton) and lure her back to the Big Apple. They meet at the Source Restaurant on Sunset Boulevard, one of LA's legendary vegetarian alfresco dining spots back in the 1970s, where the city's herbivores could tuck into such delights as the 'Aware Salad' – lettuce, grated beets and carrots, red cabbage, alfalfa sprouts, sunflower seeds, pine nuts, cucumbers, tomatoes and avocado. The choice of location for the meeting only serves to highlight how far the couple have drifted apart. Alvy cannot understand what Annie sees in LA, or 'Munchkin Land' as he calls it. Annie declares New York to be a dying city. The meeting is brief; Annie, having moved in with songwriter Tony Lacey (Paul Simon), has to accompany him to the Grammies. Alvy pursues her around the outdoor café tables as she leaves, grumbling about the West Coast obsession with handing out gongs – 'Awards! They do nothing but give out awards! I can't believe it. Greatest fascist dictator: Adolf Hitler!' – an opinion that rather reflects Allen's own indifferent attitude towards attending Hollywood's Academy Awards ceremonies. On the night *Annie Hall* won its four Oscars, Allen was honouring his regular Monday night commitment in his home town, playing clarinet at Michael's Pub on 56th Street. **→Jez Conolly**

*Directed by Woody Allen*
**Scene description: Alvy's break-up lunch with Annie at the Source Restaurant**
**Timecode for scene: 1:19:13 – 1:23:31**

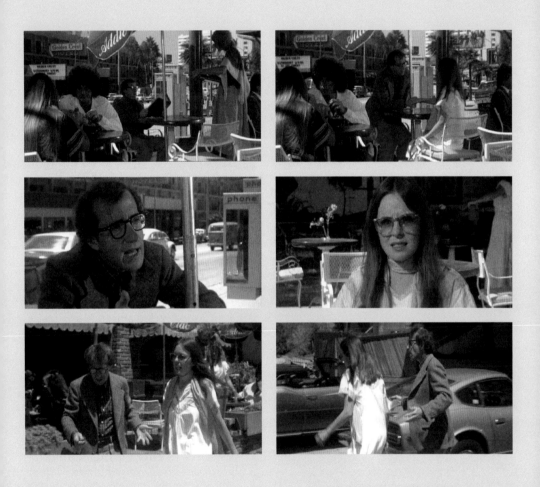

# BLACK DYNAMITE

Text by
ANDREW
SPICER

## *Film Noir and Los Angeles in the Shadows*

**HOWEVER DIFFICULT** to define precisely, film noir is about the city. Noir cities are murky labyrinths, their protagonists trapped and fearful in the dark, wet, night-time streets that glisten sinisterly with reflected neon lights. In film noir, Los Angeles – the Pacific 'city of dreams' (the location of Hollywood itself) – becomes a 'deracinated urban hell' (Davis 1998: 37); at once an actual place with famous streets (Sunset Boulevard) and recognisable landmarks (City Hall, Union Station) and a metaphoric urban space, bewildering and threatening.

Film noir fused indigenous hardboiled fiction and the expressionist heritage of European directors who had fled from Nazi Germany. *Double Indemnity* (Wilder, 1944), a quintessential noir tale of greed, murder and betrayal set in Los Angeles, was adapted from James M. Cain's novel by émigré director Billy Wilder and Raymond Chandler. Chandler was the great early chronicler of Los Angeles, its corruption, vanities and pretensions, its 'mean streets' that are 'dark with something more than night.' In noir's 'classic' period (1940–59), four Chandler novels were adapted

– *Murder, My Sweet* (Dmytryk, 1944), *The Big Sleep* (Hawks, 1946), *The Brasher Doubloon* (Brahm, 1947) and *Lady in the Lake* (Montgomery, 1947) – in which private eye Philip Marlowe investigates LA's sordid crimes, revealing a city where money is the only value. There is little attempt at a precise geography of Los Angeles; rather a concentration on atmosphere, using expressive black-and-white photography in which shafts of bright light reveal deep menacing shadows. In *Murder, My Sweet*, Marlowe (played here by Dick Powell), gazing at the glinting neon lights in the street below, muses on 'the dead silence of an office building at night – not quite real,' before a hulking figure looms up behind him. Even more fantastical was Hollywood itself, satirised in Wilder's *Sunset Boulevard* (1950) with its decaying, baroque mansion, where a faded star entraps her victim, and in Nicholas Ray's *In a Lonely Place* (1950), the story of a disillusioned screenwriter (Humphrey Bogart).

*Criss Cross* (1949), melding the realism of producer Mark Hellinger with the Germanic fatalism of émigré director Robert Siodmak was the forerunner of the movement out of the studio and into actual locations. *Criss Cross* was set in the run-down district of Bunker Hill, whose stairways, narrow alleys and funicular railway (Angels Flight) provided a visible metaphor for confusion and entrapment in an otherwise flat and featureless city (Davis 2001: 36). Bunker Hill was used in several noirs – *Night Has a Thousand Eyes* (Farrow, 1948), *Act of Violence* (Zinnemann, 1948) and *M* (1951), Joseph Losey's remake of Fritz Lang's Berlin street film of 1931. As location shooting became the norm, noir directors explored the expressive possibilities of LA's disconnected sprawl: *Armored Car Robbery* (Fleischer, 1950) featured the Downtown district with its rusting bridges, the Long Beach oil fields and

shipyard terminal. Robert Aldrich's *Kiss Me Deadly* (1955) was a conspectus, encompassing venal gumshoe Mike Hammer's apartment on Wilshire Boulevard, the newly built expressways, Bunker Hill tenements, gangster's mansions in Bel Air and the Malibu beach house where the film ends apocalyptically.

Neo-noir, developing from John Boorman's *Point Blank* (1967) onwards, extended noir's range of Los Angeles locations, even as it replaced its black-and-white *chiaroscuro* with a colour palette. Boorman, like Chandler before him, saw LA as the dystopian modern city: 'hard, cold and in a sense futuristic. I wanted an empty, sterile world, for which Los Angeles was absolutely right' (in Ciment 1986: 73). *Point Blank*'s LA is a world of steel and plate glass, desolate expressways, garish nightclubs, and the eerie emptiness of the concrete-lined bed of the Los Angeles River. Neo-noir's investigators – as in Robert Altman's adaptation of Chandler's *The Long Goodbye* (1973), *Hickey & Boggs* (Culp, 1972), and the underrated *To Live and Die in L.A.* (Friedkin, 1985) – prowled various spaces of an overwhelmingly distended metropolis, emphasising the dereliction and decay of a city that had expanded too quickly. In *Impulse* (Locke, 1990), Sunset Boulevard, where an undercover cop (Theresa Russell) plies her trade, has become a sleazy thoroughfare of sex shops, run-down hotels and drug dealing.

Although predominantly contemporary, several neo-noirs explored LA's troubled history. Roman Polanski's *Chinatown* (1974), although bathed in the warm Californian sunshine, was a bleak tale of the corruption at the heart of LA's rapid expansion in the 1930s. *L.A. Confidential* (Hanson, 1997) – adapted from James Ellroy's celebrated Los Angeles quartet – depicted the 1950s, revealing the sleaze and smut behind the veneer of Tinseltown, part of a city riddled with drugs and racketeering presided over by a corrupt judiciary. Carl Franklin's *Devil in a Blue Dress* (1995), starring Denzel Washington as a down-at-heel veteran, portrayed a racially segregated post-war LA in which colour creates barriers at every turn. Franklin's tale was representative of the burgeoning African American take on LA that began when Chester Himes 1943 novel *If He Hollers Let Him Go* finally reached the screen in 1968. Through the Blaxploitation cycle of the 1970s, and the 'hood' films of the 1990s set in the South Central district, LA's racial tensions were anatomised. Bringing a fresh perspective, Takeshi Tikano's *Brother* (2000) concentrated on the Los Angeles of immigrants and non-natives – violent, nondescript and run-down.

Contemporary neo-noirs extended these preoccupations. David Lynch's *Mulholland Drive* (2001) excoriated Hollywood's corrupt allure, as did Brian De Palma's *The Black Dahlia* (2006) – based on the first of Ellroy's quartet – which revisited the 1940s. *Dark Blue* (Shelton, 2002), from Ellroy's story, examined police corruption during the 1992 Rodney King riots, whereas *Training Day* (Fuqua, 2001) had a corrupt African American cop (Denzel Washington) as the charismatic leader of an LAPD elite unit. *Ask the Dust* (Towne, 2006) depicted Bunker Hill in the early 1930s: poverty-stricken and racist. Michael Mann's *Collateral* (2004), shot entirely at night on HDV that gave an eerie beauty to the gigantic buildings of the redeveloped Downtown, contrasted mild-mannered African American taxi driver (Jamie Foxx), for whom LA is home, with the aggressive nihilism of the white hitman (Tom Cruise), for whom LA is a disconnected city where no-one cares or notices what takes place. Although no longer the city of the future, Los Angeles retains its hold on the noir imagination. ✦

**In film noir, Los Angeles becomes a 'deracinated urban hell'**

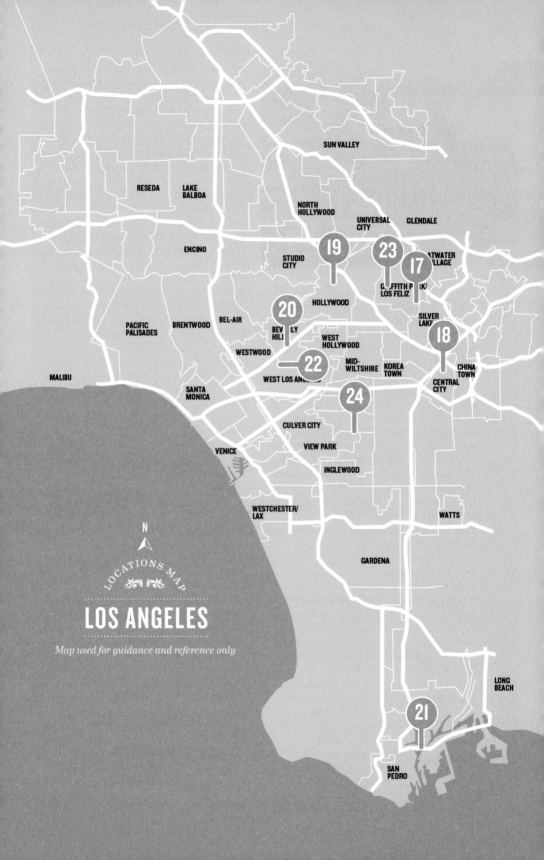

# LOS ANGELES LOCATIONS

## SCENES 17-24

# GREASE (1978)

LOCATION *The playing field at John Marshall High, 3939 Tracy Street, Silver Lake*

**GREASE IS AN EXUBERANT** adaptation of the hit stage musical of the same name, imaginatively portraying the tribulations of two cliques of high school friends – The T-Birds and The Pink Ladies. Set against the backdrop of a colourful, idealized 1950s Los Angeles, *Grease* focuses on the on-off romance between virginal Sandy Olsson (Olivia Newton-John) and bad boy Danny Zuko (John Travolta), showing what happens when oppositional teen stereotypes fall in love. Sandy's entrance into the scene is announced by the gaping expression of Danny's friends who are aghast at her transformation into a Spandex-clad, cigarette-smoking vamp. The moment Sandy flirtatiously entreats Danny to 'Tell me about it, stud...' and the couple sing 'You're The One That I Want' while dancing through the funfair located on the school playing fields, *Grease*'s high school stereotypes are turned upside-down. As couples reunite, past misunderstandings are resolved and the future happiness of the high school students looks assured as they sing 'We Go Together'. The film ends with Sandy and Danny taking flight in an airborne car; a reminder that all along *Grease* has been a fantastical evocation of both the 1950s and the teenybopper films of the era. The location for the scene, John Marshall High, featured previously in films including *Pretty in Pink* (Deutch, 1986) and *Buffy The Vampire Slayer* (Rubuel Kuzui, 1992). However, the exterior of *Grease*'s Rydell High belongs to another oft-used Californian locale, Venice High School, which has appeared in films such as *A Nightmare on Elm Street* (Craven, 1984), *Matchstick Men* (Scott, 2003) and *American History X* (Kaye, 1998). ∙∙ **Victoria Williams**

*Directed by Randal Kleiser*
**Scene description: A freshly made-over Sandy joins the end-of-term funfair**
**Timecode for scene: 1:42:24 – 1:44:49**

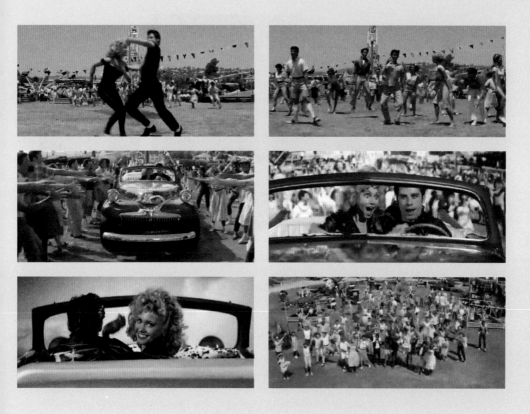

# BLADE RUNNER (THEATRICAL CUT) (1982)

LOCATION *The Bradbury Building, 304 South Broadway, Downtown*

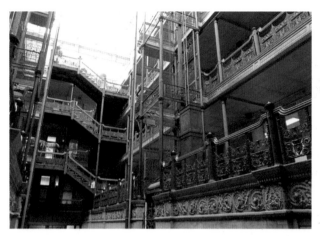

**RIDLEY SCOTT'S** cyberpunk vision of the future, *Blade Runner*, is set in the Los Angeles of 2019, a perpetually rainy city inhabited by a multi-ethnic population after wealthy earthlings have relocated 'off-world'. The film chronicles policeman Rick Deckard's (Harrison Ford) struggle with his humanity, vulnerability and loneliness as he hunts down four 'replicants' – androids endowed with emotions who, wishing to live longer, have returned to Earth to find their creators. *Blade Runner* foregrounds creative activities, yet one of its strongest reflections on creation takes place in a run-down version of an iconic Downtown Los Angeles location: the Bradbury Building. This stunning five-storey office building was designed by George H. Wyman and built in 1893, with a then-futuristic skylight that illuminates its central court, highlighting the Renaissance-styled, wrought iron railings and the open corridors that create a sense of structure and harmony. *Blade Runner* plays the Bradbury against itself, giving the building's most distinctive features a dream-like quality that suggests the blurring of boundaries between creation and death, human and replicant, numbness and feeling. Permeated by the surrounding smog, the dark, dank and dusty Bradbury has become the residence of genetic engineer J.F. Sebastian (William Sanderson). Only distant neon advertisements and moving spotlights filter through its skylight, muting the interior's terracotta tones, while dolls and other human likenesses clutter its corridors. Introducing herself to J.F., her maker, as 'sort of an orphan' who is 'lost', replicant Pris (Daryl Hannah) enters the building with him and wonders if J.F. gets lonely living there. J.F. responds by explaining that he makes his friends – animated toys – and the meek genetic engineer's enjoyment of Pris' company later reveals his inability to connect with humans. **↝ Isis Sadek**

Directed by Ridley Scott
Scene description: 'It must get lonely in here, JF'
Timecode for scene: 0:37:52 – 0:42:09

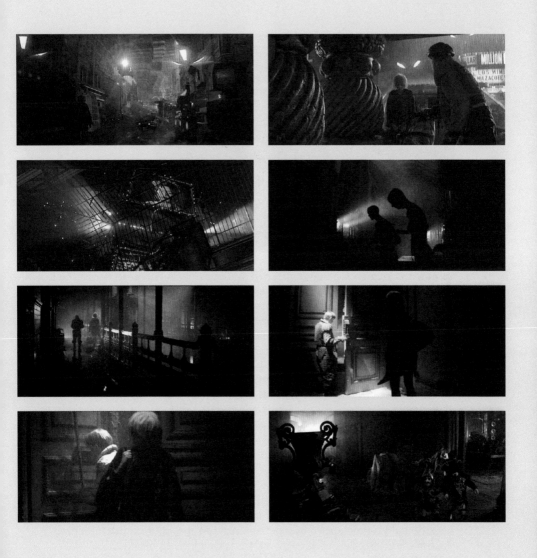

# BODY DOUBLE (1984)

LOCATION *Chemosphere House, 3105 Torreyson Place, off Mulholland Drive*

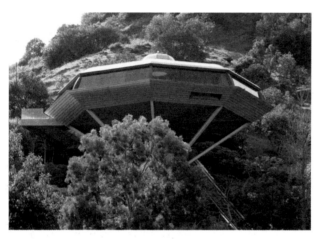

**BRIAN DE PALMA'S** 1980s erotic thriller, *Body Double*, is obsessed with surfaces – their appealing gloss, their seductive familiarity, their ability to conceal the truth. Fittingly, then, it flits across a number of famous LA locations like a tourist browsing through postcards: we go shopping on Rodeo Drive, have coffee at the Farmer's Market on West 3rd Street, drink neat Jack Daniels at Barney's Beanery in West Hollywood, and get a hot-dog at Tail o' the Pup on San Vicente. One location, however, encapsulates the film's central conceit: that even when we think we see everything, we can miss what is right in front of our eyes. John Lautner's iconic Octagonal house, the Chemosphere, offers a panoptic 360-degree view of the city, appearing to show its occupant everything Los Angeles has to offer. The struggling actor, Jake Scully (Craig Wasson), is offered the chance to stay in these luxurious digs after his girlfriend cheats on him and kicks him out. Down on his luck and achingly naïve, Jake accepts his good fortune at face value, though later he will pay a heavy price. Yet Jake has ample warning. When we first meet him, he is on set at a studio, surrounded by fake graves, trees and smoke. As he goes to his car, he dodges backdrops of sunsets and palm trees. Even his relationship with his girlfriend is proclaimed by a personalized neon wall-decoration reading 'Jake ♥ Carol'. Yet despite losing both his acting job and his girlfriend, Jake maintains a child-like faith in surfaces. As he is shown the various luxuries of the Chemosphere – including a rotating bed, a built-in tropical aquarium and a personal bar – Jake coos with excitement at each new discovery. And as he and his benefactor look out over the town and toast 'To Hollywood,' Jake can only sigh in assent, and whisper, 'Man, what a view!' **◄◄ Martin Zeller-Jacques**

*Directed by Brian De Palma*
**Scene description: 'Man, what a view!'**
**Timecode for scene: 0:17:50 – 0:19:36**

# BEVERLY HILLS COP (1984)

LOCATION *Beverly Hills City Hall, 455 North Rexford Drive, Beverly Hills*

**AT HEART BEVERLY HILLS COP** is the classic fish out of water tale told with a modern twist. Detroit policeman Axl Foley (Eddie Murphy) heads to Beverly Hills on the trail of his best friend's killer. Snooping around the 'Emerald City' like a sniffer dog at a high-class party, Foley uses myriad tricks to outwit and outsmart both cop and crim alike – always staying one step ahead of the game as he closes in on his target – bad guy Victor Maitland (Steven Berkoff). Juxtaposing Foley's rough hewn, smart and sassy Detroit cop against the affluent, buttoned-up veneer of Beverly Hills sets up a volley of comedic moments which the movie exploits to full effect. Foley's first encounter with Beverly Hills law enforcement follows his arrest at Maitland's office when he gets thrown through a window for asking one too many questions. The subsequent backseat ride to police headquarters affords Foley the first of many opportunities to sarcastically rib the 'locals': 'Officers, if we see any movie stars, could you point them out to me cos' I've never seen any shit like that.' Pulling up outside a rather grand looking police precinct, Foley is led inside but not before admiringly stating that 'This is nice!' The upmarket cop shop is actually the splendid 1932 Spanish-Baroque Beverly Hills City Hall on North Crescent Drive at Santa Monica Boulevard. One of the city's most beloved icons, the building was designed by architect William Gage and features prominently in all three Beverly Hills movies. **➻Gabriel Solomons**

*Directed by Martin Brest*
**Scene description: Axel gets arrested for the first time**
**Timecode for scene: 0:00:13 – 0:04:10**

# TO LIVE AND DIE IN LA (1985)

LOCATION *The Vincent Thomas Bridge, San Pedro*

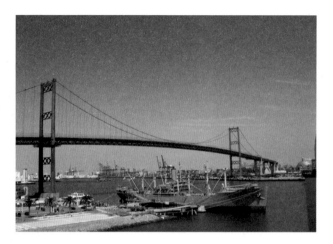

**ALTHOUGH RIDDLED** with genre clichés and terribly dated (due in part to its Wang Chung score), William Friedkin's slick and stylish thriller is an effective slice of 1980s cinema that skewers some conventions with its focus on amoral, unlikable characters and inclusion of a downbeat, nihilistic ending. Considered by many to be the sun-kissed alter-ego to the director's earlier New York set cop thriller *The French Connection, To Live and Die in L.A.* is a film absolutely captivated by the appearance of things, and thus a perfect film to be set in Los Angeles. Central to the film is the character of Richard Chance, the aptly named loose cannon cop out for revenge, whose appetite for thrills will steer him (and others) rapidly off the rails as the story unfolds. We get an early taster of this recklessness when Chance is seen bungee jumping off a bridge. At first it seems like a suicide attempt – the cop staring blankly into the distance, the demons perhaps finally getting the better of him. Then off he leaps and we get to see the safety line tied to his trouser leg, which prevents the fatal descent into the abyss. The bridge that Chance jumps off of is the Vincent Thomas Bridge in San Pedro which links the mainland of the Los Angeles Harbor with Terminal Island. Opened in 1963, the bridge – the fourth longest suspension bridge in California – was built to replace the ferries that connected San Pedro and Terminal Island, in anticipation of increased traffic that would eventually accompany the port's growth. Notable for its prominent appearance in a few other scenes from *To Live and Die in L.A.*, the bridge is also in a scene from Michael Mann's 1995 film *Heat* but is misidentified as the "Vincent St. Thomas Bridge". ➥*Gabriel Solomons*

*Directed by William Friedkin*
**Scene description: Chance takes a leap off the Vincent Thomas Bridge**
**Timecode for scene: 0:08:30 – 0:09:28**

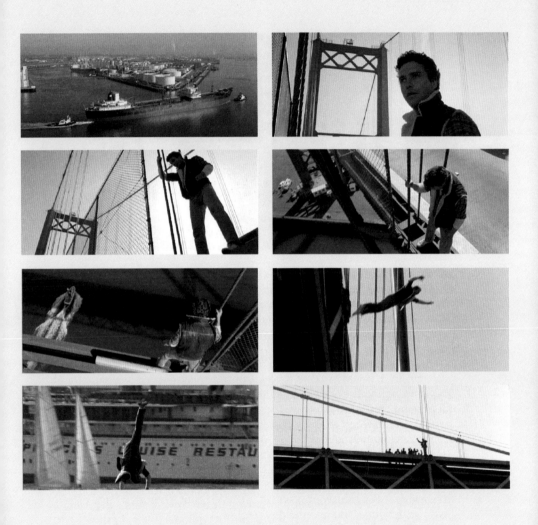

# DIE HARD (1988)

*Fox Plaza, 2121 Avenue of the Stars, Century City*

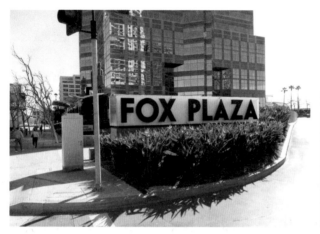

**DIE HARD** was a watershed moment in the development of the action movie, adding a whip-smart script without a scrap of fat, as well as a hero who mixed some real humanity in with his muscles, to create as near a perfect entertainment as Hollywood has ever produced. But despite all the tough stuff, the one liners and the iconic moments of inspired destruction, the real star of this movie is the Nakatomi Plaza (in reality, Fox Plaza, in Century City): the skyscraper where all the action takes place. The tower looms over Los Angeles like Olympus over Ancient Greece, and quickly enough it becomes the playground of the gods, as Bruce Willis fights to wrest it from Alan Rickman's army of Aryan übermenschen. In this scene, however, the decidedly mortal police sergeant, Al Powell (Reginald VelJohnson), gets his first glimpse of the mountaintop. We meet him stocking up on cakes in a twenty-four hour convenience store. His prosaic banter with the clerk reminds us that he is unaware of the events which are about to overtake him. Leaving the store, Al receives a call from dispatch, ordering him to investigate a disturbance at Nakatomi Plaza. He accepts without thinking about it then slowly lifts his eyes to the distance. The camera follows his gaze, rising above the gas station and the lights of the city to rest upon the peak of the skyscraper. Barely visible on top of the building are the bright flashes of gunfire, from this distance, as calm and quiet as the twinkling of stars. This will be the last quiet moment of Al Powell's night. ❧***Martin Zeller-Jacques***

*Directed by John McTiernan*
**Filming location: Al Powell joins the party**
**Timecode for scene: 0:43:30 – 0:44:26**

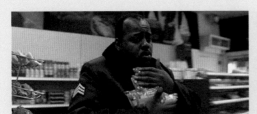
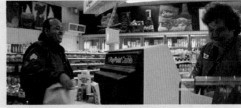

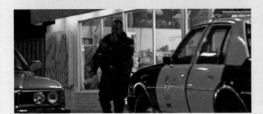

# WHO FRAMED ROGER RABBIT (1988)

LOCATION *East Observatory Avenue Tunnel at Griffith Park*

**PRIVATE EYE** Eddie Valiant (Bob Hoskins) hates toons and, therefore, hates Toontown, where cartoon characters from Mickey Mouse to Bugs Bunny and from Dumbo to Daffy Duck pass a peaceful, if chaotic, co-existence. Now, embroiled in 'a story of greed, sex and murder,' he must head into what is, for him, a hand-drawn Hell hole. This will take the old Eddie Valiant: the one who frequently worked Toontown before 'a toon killed his brother' by dropping 'a piano on his head'. Standing in front of the tunnel to Toontown (in real life, the Vermont Avenue Tunnel at Griffith Park, 4730 Crystal Springs Drive), Valiant takes out a huge cartoon revolver and loads it with sentient – if stupid – bullets ('dumb-dumbs', he calls them later). He reaches for a drink, but reconsiders. It plays like a pre-emptive parody of those moments in *Unforgiven* (Eastwood, 1992) when Clint Eastwood's character readies himself to return to his outlaw ways and re-enter the town of Big Whiskey; with the difference being that, for Eddie Valiant, the bourbon in the bottle he discards has been emphatically un-imbibed. He drives into the tunnel. At first it is normal; the only incongruity is that, in an old cinematographer's trick to ensure better images, the road surface is wet. (How could it have rained inside a tunnel?) And then cartoon curtains appear, open, and – in one of cinema's smoothest combinations of live action and animation – a thousand singing, grinning, dancing, flying toons welcome Eddie, and us, to Toontown. **•Scott Jordan Harris**

*Directed by Robert Zemeckis*
**Scene description: Welcome to Toontown/The Tunnel to Toontown**
**Timecode for scene: 1:05:12 – 1:07:53**

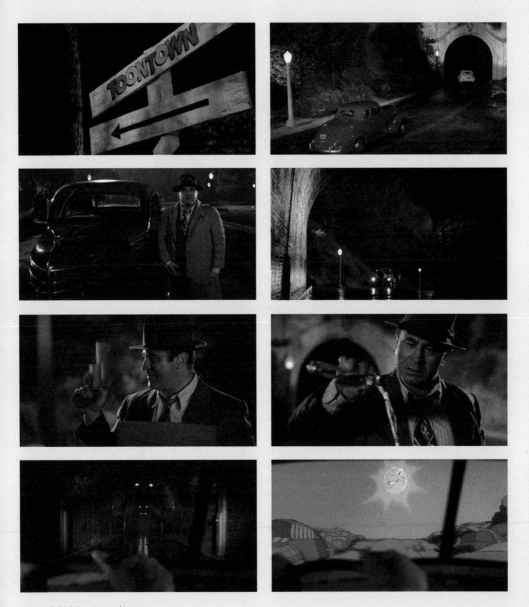

# BOYZ N THE HOOD (1991)

LOCATION ⟩ *5906 Cimarron Street, South Central Los Angeles*

**IN *BOYZ N THE HOOD*'S** most famous line, Doughboy (Ice Cube) laments, 'Either they don't know, don't show, or don't care 'bout what's going on in the 'hood.' John Singleton doesn't simply 'show' viewers South Central, he immerses them in it – a feat accomplished through sound. The film begins without an establishing shot. Indeed, the only shots in the first frames are the gunshots that blare on the audio track. The sounds of this firefight give way to the voice of a dispatcher who solicits a police response to a '187 at the corner of Crenshaw and Century.' As a child cries out, 'They shot my brother,' the audio drops off and the film cuts to a stop sign, cinematically establishing the movie's tagline: 'Increase the Peace.' *Boyz* again constructs location through audio when, overcome by the brutality of the area's police and gangs, the protagonist, Tre' (Cuba Gooding, Jr.), seeks comfort in the home of his girlfriend, Brandi (Nia Long). In South Central, however, there are few havens from the wars – on drugs and between gangs – raging outside. Noise from police helicopters penetrates the walls of the single-family home and Brandi comments, 'I'm tired of hearing them shooting.' Tre, too, is tired. Here, he suffers a breakdown. Punching the air, he threatens to take on all who get in his way. But by not following through on his violent threats, Tre is the lone man to escape the police state and gangland of South Central when the film concludes. ⤏ *Benjamin Wiggins*

*Directed by John Singleton*
**Scene description: Tre's breakdown at Brandi's house**
**Timecode for scene: 1:13:59 – 1:16:27**

# GETTING PLAYED

Text by
BENJAMIN
WIGGINS

*Hollywood, South Central and the Space Between*

**DESPITE BEING** just miles from the film-making capital of the world, South Central Los Angeles was rarely seen on camera prior to the boom of so-called 'hood' films in the 1990s. Melvin Van Peebles's 1971 film *Sweet Sweetback's Baadasssss Song* and Charles Burnett's *Killer of Sheep*, filmed in 1972, represent some of the first stories told by black directors about black Los Angelenos. And since decades of segregation forced Los Angeles' black population into a three square mile area south of Washington Avenue, west of South Central Avenue, north of East Vernon Avenue, and east of where the Harbor Freeway now stands (Sides 2003:17), South Central was the necessary setting for movies about black life in Los Angeles. Van Peebles' film displays the area's industrial side, fragmented by the Southern Pacific Railroad tracks and the concrete bed of the Los Angeles River. Burnett's much quieter picture meditates on the block near Towne Avenue and East 99th Street where he grew up.

Even as the area grew to encompass a 50

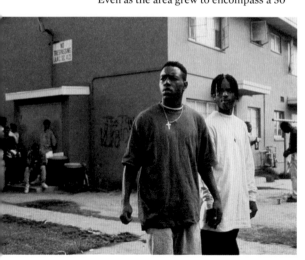

square mile territory that stretched from the Crenshaw District to Carson, and even after *Sweetback's* immense success demonstrated that films featuring African Americans were viable commodities, Hollywood left South Central off its celluloid. The gangs, the violence and the drugs featured in the 'hood' films explosion of 1990s were already prevalent by at least the early 1970s. But as the philosophers of media, Max Horkheimer and Theodor Adorno note, Hollywood 'rejects anything untried as a risk' (2002: 106). It took the success of Spike Lee's Brooklyn picture *Do the Right Thing* (1989) to make films about the 'hood' appear profitable enough for studios to invest in.

John Singleton's *Boyz n the Hood* (1991), which takes place in Chesterfield Square, Inglewood, and Compton brought the genre from New York to Los Angeles. And while it goes to great lengths to identify its location – for instance, Singleton's lens lingers on street signs such as 3300W Lawrence Street – *Boyz* does not exoticise South Central. In the film only muted colours mark gang members, and drug deals are shown in wide-angle implying that they are just another patch in the fabric of the neighbourhood. While Singleton strove to illustrate the community of his youth, the film's marketers sold the picture as an otherworldly fairy tale with the tagline, 'Once Upon a Time In South Central LA.'

*Boyz* was released in July of 1991. By the following April, South Central was in flames. Spurred by the acquittal of the LAPD officers that brutally beat Rodney King, residents rioted for six days, resulting in over one billion dollars in damage and 53 deaths. Though news coverage portrayed the violence as contained within South Central, and constructed the uprising as a response of the black community to the verdict, rioting occurred

throughout many parts of Los Angeles County and the role of race in the episode was hardly black and white.

In the wake of Singleton's success and the notoriety of the riots, Warner Brothers quickly released the *Boyz*-copycat, *South Central* (Milburn Anderson, 1992). Then New Line Cinema produced *Menace II Society* (Albert and Allen Hughes, 1993), which, save for *Boyz*, is the most complex of the South Central 'hood' films.

Taking place in Watts, *Menace* opens in a Korean American-owned liquor store – perhaps one of the most contentious spaces in America at the time. News media may have depicted the riots as random violence, but historical studies show that rioters systematically targeted Korean American-owned businesses. In this tense scene, racially tinged quips exchanged between the young, black protagonists and the storeowners steadily fill the air and surround the four characters like a gas leak. When the clerk makes a derogatory remark about one boy's mother, the youth blows up and shoots the husband-and-wife owners to death.

*Menace* is not coy in connecting itself with the riots. The scene following this opening vignette

**Even after *Sweetback's* immense success demonstrated that films featuring African Americans were viable commodities, Hollywood left South Central off its celluloid.**

shows black-and-white footage of the 1965 Watts Riots then skips ahead to present-day Watts. Yet, rather than work through the racial politics of its prologue, *Menace* implies that 1992 was simply a repeat of 1965. Few consequences come of the events that took place in the liquor store, and a short flashback set in 1970s Watts establishes that the characters' behaviour in 1993 has changed little from the generation before.

*Menace*'s promotional materials tout the film's credibility, stating, 'This is the truth. This is what's real.' However, by the time Hollywood developed an interest in portraying African Americans living in South Central, the area's demographics had shifted. Latinos represented 45 per cent of the South Central population in 1990 (Meyers 2002: i) and yet were nearly absent from *Boyz*, *South Central* and *Menace*, as well as later films in the genre such as *Poetic Justice* (Singleton, 1994) and *Set It Off* (Gray, 1996). Latinos don't factor prominently into any South Central-based movies until Larry Clark's *Wassup Rockers* (2005) and Scott Hamilton Kennedy's *The Garden* (2008), which, like *Sweetback* and *Killer* before them, are independent productions.

Hollywood mined South Central until the land could only yield parodies of itself. 1996's *Don't Be a Menace to South Central While Drinking Your Juice in the Hood* (dir. Barclay) – in which Singleton's 5900 block of Cimarron Street and the Hughes brothers' Jordan Downs Projects are replaced with 6969 Penetration Avenue and 187 Drive By Blvd – cannibalized the genre.

Studio films fail to illustrate the richness and dynamism of South Central. But movies that show the current and historical social forces that shape a city such as *Chinatown* (Polanski, 1974) or *Gangs of New York* (Scorsese, 2002) are rare. Indeed, film may be a medium ill-suited to demonstrating the depth of a location. In recent serial television shows such as *The Wire* and *Boardwalk Empire*, David Simon's West Baltimore and Terrence Winter's Atlantic City shoreline demonstrate that place is as important as character in visual drama. Will Hollywood ever invest in such an extended depiction of South Central or will the popular image of its neighbor to the south remain synonymous with the 'hood genre? ✤

# LOS ANGELES LOCATIONS

## SCENES 25-32

# L.A. STORY (1991)

*Windward at Speedway, Venice Beach*

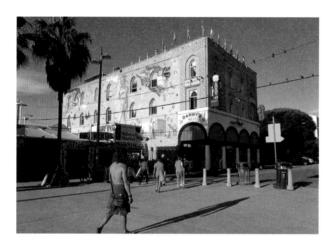

**OPENING SCENES** often tell us so much about what to expect from a film. As Charles Trenet's wistful tune 'La Mer' gently segues into a shot of glistening water, a bevy of bikini-clad beauties poolside and then a seemingly gravity defying giant twirling hot dog, we know to expect the unexpected. Steve Martin's love letter to his adopted home town (he was born in Texas) endearingly skewers many LA stereotypes and caricatures, aspects of the city that can be guffawed at by both long-time residents and 'tourists' alike. A cartoon-like brushstroke is applied to accentuate themes of dislocation, vanity, fickleness and greed as the comedy stick pokes fun at obvious targets like the 'power' lunch, daily commute, consistently inconsistent architecture, and ditsy tweenagers – gloriously embodied by Sarah Jessica Parker's SanDeE*, Harris Telemacher's (Martin) lust interest in the film, who lives, appropriately enough, in Venice Beach. Much as Greenwich Village is the 'hip' middle to Manhattan's wider 'hop', so it can be likened to Venice Beach's relationship to Los Angeles as a whole. The scene of Harris and SanDeE* strolling back to her apartment, nonchalantly discussing enemas while a gaggle of carnivalesque activity ensues around them, beautifully illustrates the peculiar wonder of the place. Good use is also made of famed Venice Beach artist Rip Cronk's building length mural at Speedway and Windward Avenue, which acts as a colourfully animated background to the absurdly romantic dialogue. •• **Gabriel Solomons**

*Directed by Mick Jackson*
**Scene description: Harris and SanDeE\* take a stroll**
**Timecode for scene: 0:40:37 – 0:41:46**

# BUGSY (1991)

*Los Angeles Union Station, 800 North Alameda Street*

**CALIFORNIA'S ICONIC GATEWAY** to the north – the Golden Gate Bridge – has a sister entrance in Southern California: Union Station. A wide shot announces the elegant station, imposing in cream with high terracotta entranceway and great windows large enough for a giant to peep through. Matchstick palm trees tower higher still as a pair of Ford Model Ts arrive and depart, travellers milling on foot. Our East Coast gangland protagonist, Bugsy (Warren Beatty), arrives at the golden Art Deco station, and a musty nostalgia for Los Angeles of the 1930s emerges. A comfortable distance from the Spanish Missions of the south, the city is instantly recognisable as his actor friend is shrouded by enraptured fans. The moment perfectly captures the seduction of Classical Hollywood glamour into which Bugsy becomes swiftly enticed. The marble interior – home to the quick click of high-heeled footsteps and bustle of bellhops – bestows glamour and timeless class to the station's interior. A step above the Greyhound, this was the first-class flight suite of the 1930s. Striding importantly across the smoky waiting room, Bugsy and George (Joe Mantegna) have business to attend to in Hollywood. Cruising in style beneath the Sierra Nevada, home to the monumental Hollywoodland sign, the essence of Los Angeles as the home of the movies is captured on film. Palm trees pierce the skyline and LA's landmarks pop up amongst the still, green foothills, giving a taste of the city's physical growth and budding prosperity; of the high life which Bugsy is about to enter. **•Nicola Balkind**

*Directed by Barry Levinson*
**Scene description: Bugsy meets George at Union Station**
Timecode for scene: 0:09:53 – 0:11:00

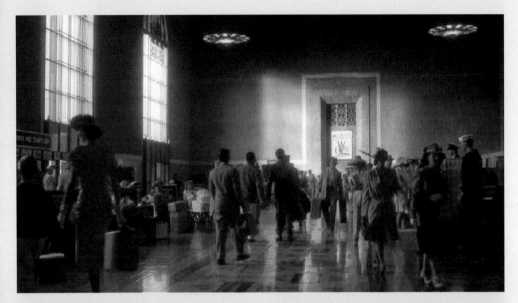

# BARTON FINK (1991)

*Zuma Beach and Point Dume State Beach, Malibu*

**BARTON FINK** doesn't know what he's doing in Hollywood. After all, as he keeps reminding us, he's an artist. Yet, from the moment he arrives in Los Angeles he acts like a cheap hack – in hopeless, unrequited love with the idea of art, but unable to produce it. Amid the self-imposed squalor of his hotel room, the only hint of inspiration comes from a cheap print hanging on the wall; it depicts a girl sitting on a beach, staring out to sea with one hand raised to shade her eyes. Several times throughout the film, this picture offers a counterpoint to the gloom and emptiness of urban LA, and the beach asserts itself as the sound of surf intruding into Barton's hotel room. Yet only in the last scene of the film does Barton finally see the real beach. The scene, which takes place at Zuma Beach, a popular film location also seen in *Planet of the Apes* (Schaffner, 1968) and numerous *Baywatch* episodes, emphasises the expansive shoreline which, unconfined by a picture frame, is just as empty and isolating as the rest of the city. As Barton arrives on the beach, he is greeted by a girl resembling the one from the picture. For a moment Barton seems hopeful again, and as the girl sits in front of him, he compliments her on her beauty, and asks, 'Are you in pictures?' Her reply is at once casual and crushing: 'Don't be silly.' Then she turns away, stares out to see and lifts her arm to mirror the pose of the girl in the picture. And just to emphasise the distance between the picture and what it depicts, at that moment, a seagull falls out of the sky to drown in the waves and the movie ends. ➻**Martin Zeller-Jacques**

Directed by Joel Coen
**Scene description: 'Are you in pictures?'**
**Timecode for scene: 1:46:32 – 1:48:33**

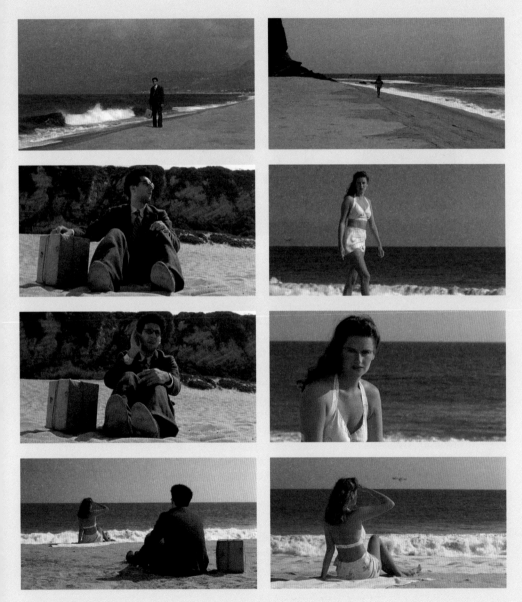

Images ©1991 Circle Films

# THE DOORS (1991)

LOCATION

*The Viper Room, 8852 Sunset Boulevard and Whiskey Go-Go - 8901 Sunset Boulevard on the Sunset Strip, West Hollywood*

**THE BUILDING NOW HOME** to the Viper Room on Sunset Boulevard was used by Oliver Stone as stand-in for the London Fog nightclub, the Sunset Strip venue for numerous early live performances by the Doors prior to their elevation to house band at the Whisky a Go Go right across the street. The London Fog, these days occupied by a humble nail and beauty salon (although the nearby Duke's Coffee Shop is frequently cited as its original location) was the band's cradle. It was where they came together musically to develop their distinctive sound and in the featured scene we are party to the emergence of singer Jim Morrison (Val Kilmer) from shy retiring type to flamboyant performer. His back to the audience during a relatively reticent run-through of 'Break on Through (To the Other Side)', Morrison is urged on by keyboardist Ray Manzarek (Kyle MacLachlan) to turn and face his public. This he eventually does, much to the delight of the young females dancing next to the stage who are witness to the birth of a legend. *The Doors* was released in 1991 and it was a couple of years before the location for the scene opened its doors as the Viper Room, a club part-owned until 2004 by Johnny Depp. Not long after opening its place in pop culture folklore was secured when actor River Phoenix, perhaps channelling the self-destructive spirit of Morrison, suffered a fatal drugs overdose within its walls. **•• Jez Conolly**

*Directed by Oliver Stone*
**Scene description: Early Doors performance at the London Fog nightclub**
**Timecode for scene: 0:20:34 – 0:25:55**

# AMERICAN ME (1992)

*Corner of Main Street and 5th Street, Downtown*

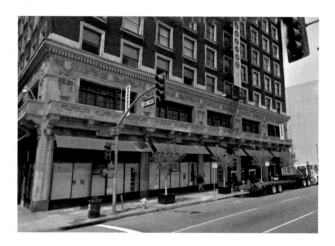

**THE 'ZOOT SUIT RIOTS'** of June 1943 transformed Downtown Los Angeles and the ethnically diverse adjacent neighbourhoods into a war zone. *American Me* revisits these strife-torn streets at a pivotal moment in the discrimination against Mexican Americans across the country. Hopping to the sounds of swing, the downtown area's dance halls witnessed the consolidation of the zoot suit culture and its particular brand of masculinity. The zoot suit made ample use of cloth in times of scarcity, symbolizing the newfound pride and assertiveness of a generation of young Mexican Americans (*pachucos*) growing increasingly impatient with discrimination. Feeling threatened by these *pachucos*' defiant attitudes, servicemen stationed in Los Angeles eagerly sought out these perceived enemies. 'On the night of the Zoot Suit Riots in 1943, Pedro and Esperanza had a date,' a pensive Santana (Edward James Olmos) recalls from his prison cell. Then, near Main and 5th, a radiant and stylish Esperanza steps off the streetcar and meets her friends. While the trio looks forward to dancing, Marines hover nearby, and radios broadcast anxious commentary about the riots. Tragedy ensues in the tattoo parlour where Pedro, Esperanza's future husband, is immortalizing his love for her. With the rose's red ink still drying on Pedro's flesh, Marines storm into the shop, drag him out onto the street and beat him, while raping Esperanza. The suit's fabric tears almost as loudly as the victim's screams, and the evening's promise of love is shattered. As Santana, the product of this rape, tells us, this night sealed his fate as a criminal, thrusting him into a lifelong struggle between love and hatred, pride and victimhood, toughness and feeling. ➔ **Isis Sadek**

*Directed by Edward James Olmos*
**Scene description: 'The streets are getting hot ese'**
**Timecode for scene: 0:02:44 – 0:08:56**

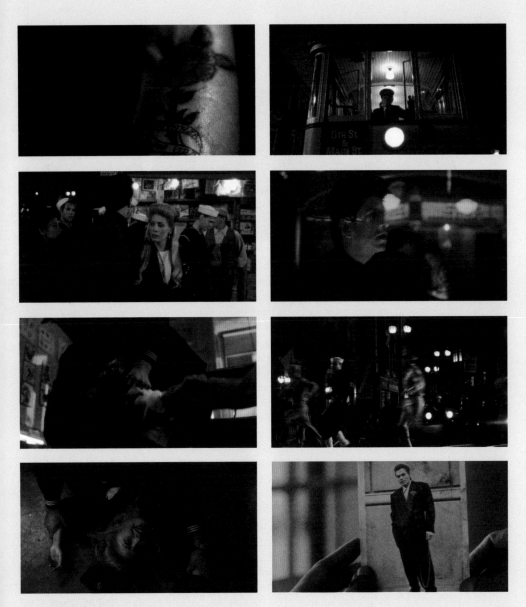

# THE PLAYER (1992)

## Hollywood Forever Cemetery, 6000 Santa Monica Boulevard

**ROBERT ALTMAN'S** adaptation of Michael Tolkin's novel *The Player* is a dark, satirical portrait of the less salubrious side of Hollywood. Tim Robbins' Machiavellian studio executive Griffin Mill, blackmailed and stressed, literally gets away with murder in this scabrous, blackly comic exposé of Tinseltown. Altman's extensive location shooting in and around Los Angeles takes in the iconic Sunset Boulevard, The Los Angeles County Museum of Art and The Rialto Theatre, South Pasadena, amongst many others. In terms of narrative, however, the scene in the Hollywood Forever Cemetery on Santa Monica Boulevard is the most richly symbolic sequence in the film. Griffin makes a brazen appearance at the funeral of his victim – struggling screenwriter David Kahane – who is symbolized by a shot of a dead fish floating in a cemetery pond. In *The Player's* most pointed comment on the underlying coldness and vacuousness existing in Hollywood, the Hollywood Forever Cemetery plays an essential role. Founded in 1899 and bordering the back of Paramount Studios, the palatial cemetery celebrates Hollywood itself as much as the lives of those interred there. The ostentatious, 62 acre grounds are listed on the National Register of Historic Sites and host walking tours, film screenings and concerts. Amidst the palm trees and immaculately tended plots, Griffin and Jane (Greta Scacchi) pay lip service to the departed and lay the foundations for their own subsequent troubled relationship. In Tolkin and Altman's hands Hollywood Forever is a place where the networking never stops, secrets are buried and the dream factory rolls on absolved of any guilt. **➻ Neil Mitchell**

*Directed by Robert Altman*
**Scene description: Griffin meets June at the funeral of David Kahane**
*Timecode for scene: 0:45:26 – 0:49:51*

# FALLING DOWN (1993)

*Venice Fishing Pier, Venice Beach*

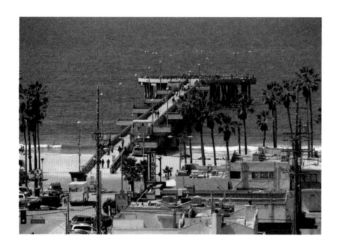

**IN THE FINALE** of *Falling Down* William 'D-fens' Foster (Michael Douglas) runs up the Venice Fishing Pier to be reunited with his estranged wife (Barbara Hershey) and daughter. However, his day of rampage and violence throughout the city has ensured that Detective Prendergast (Robert Duval) is right behind him – setting up the final showdown between perpetrator and dogged pursuer. Four kilometres in length and opened in 1964, the Venice Fishing Pier is – as the name suggests – primarily used for fishing; but unlike other piers in the area, such as the Santa Monica Pier slightly north up the coast, has no amusements or rides cluttering its extended reach out to the ocean. This, therefore, makes it an ideal location for the climax of D-fens' troubled (and troubling) day. His journey had to end at the ocean. He had spent all day trawling the streets of Los Angeles in a fury at the state of the city and what has become of both it and himself. It's the kind of journey or odyssey that has to end at the sea; where the city finally stops and yields to the environment; where it can expand no further. It is therefore convenient that D-fens' old family home (the place he is no longer welcome but struggles to get back to all day) is situated right on Ozone Avenue on Ocean Front Walk, adjacent to the pier. The lack of buildings and attractions on the pier provides an un-obscured view of the climactic events that take place, and the sparse setting heightens William 'D-fens' Foster's empty final realisation: 'You mean, I'm not the good guy?' ➼ **Toby King**

(Photo ©Alek Solo)

Directed by Joel Shumacher
Scene description: Final showdown with Detective Prendergast
Timecode for scene: 1:32:00 – 1:42:10

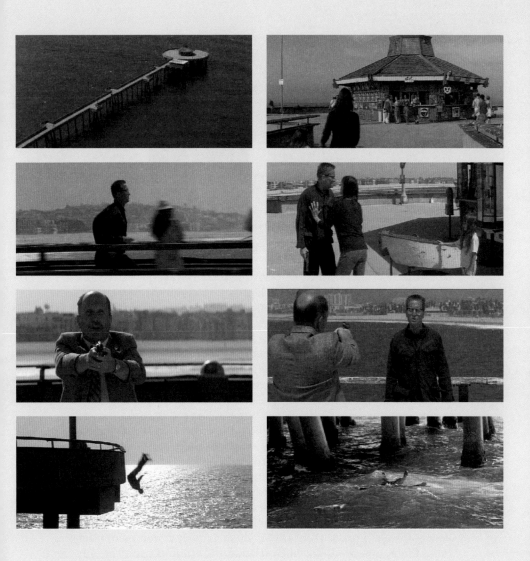

# SPEED (1994)

LOCATION *Harbor 110 and Century 105 interchange, Century 105 Freeway*

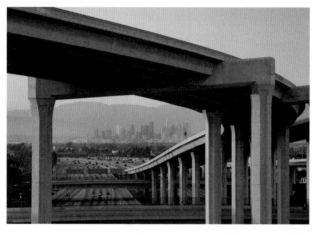

**REDEFINING** the meaning of the term 'road movie', the high concept thriller *Speed* turns a by-the-numbers action plot into a suspense master class. Trapping a multicultural ensemble cast in a cramped city bus with a bomb in its belly, *Speed* plays like *Stagecoach* (Ford, 1939) on, well, speed. The 2525 bus makes its increasingly terrifying journey from the centre of Los Angeles to the LAX airport, where it can safely circle the runway. In reality, however, most of the action was filmed on the yet to be completed Century 105 Freeway. Ironically, the pivotal scene in the film involving an unfinished road required a bit of movie magic to artificially remove a section of the ramp between the Harbor 110 and Century 105, over which the bus makes a fifty foot jump. The scene is a masterful suspense set-piece. The isolation of the passengers on the bus has already been emphasised by their move from the packed freeway to an empty stretch of road shared only by their police escorts. One by one, these peel away as the camera tracks past the bus to rest on the empty space it must cross – the last and most daunting of the obstacles lying between it and the airport. As the music reaches its crescendo, we jump cut in turn to every one of the passengers as they duck, hide and pray, before the bus takes flight. Several different camera angles track its agonising progress, as it seems to hang for an age in the air, before falling to safety on the other side. ➡ *Martin Zeller-Jacques*

(Photos ©Geoffrey George / ©rhinocarhire.com)

*Directed by Jan de Bont*
**Scene description: The leap of faith**
**Timecode for scene: 0:59:45 – 1:04:40**

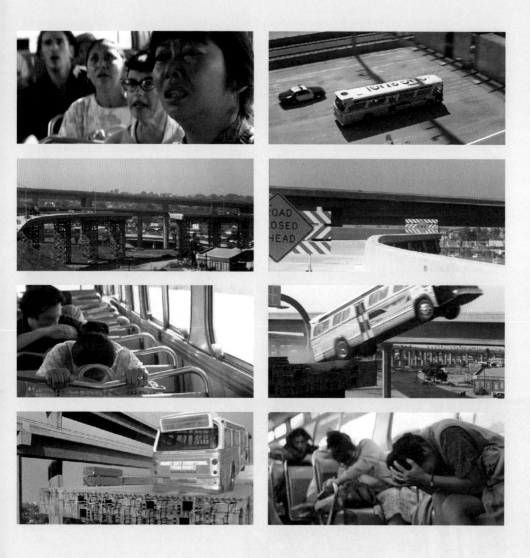

Images ©1994 20Th Century Fox

# WELCOME TO HELL-A

Text by
MARTIN
ZELLER-
JACQUES

CALIFORNIA IS THE PROMISED LAND of the American myth; the destiny the Pilgrims finally made manifest in an endless vista of sun, sand and surf. And LA is the jewel in its crown; home to Hollywood, a magical dream factory where a little bit of luck can turn a small-town nobody into a star. Yet underneath the surface LA is also a place of broken promises and dying dreams, where would-be starlets succumb to Faustian bargains and lives are wasted in pursuit of impossible goals. The myth of California, and specifically LA, as Hell on Earth is powerful and persistent. There is a devilish irony to the idea that, although from the outside Los Angeles appears to be a paradise, people on the inside are clawing at the walls to get out. Plenty of films about the city have a whiff of brimstone about them: whether it's the back room of the neo-Nazi shopkeeper in *Falling Down* (Schumacher, 1993) or the sadistic sex dungeon in *Pulp Fiction* (Tarantino, 1994); the surface of glamour which conceals Mephistophelean figures like Noah Cross or Kaiser Soze in *Chinatown* (Polanski, 1974) and *The Usual Suspects* (Singer, 1995); the macabre

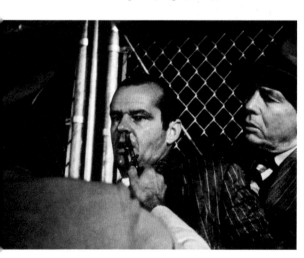

prostitution ring with girls surgically altered to resemble movie starlets in *L.A. Confidential* (Hanson, 1997); and, of course, the mind-bending, inscrutable and omnipresent horror of *Mulholland Drive* (Lynch, 2001).

However, some movies take their fascination with Hell-A further, making it the centre of their narrative worlds. In particular, science fiction and fantasy movies have explored this territory, and even extended it to the outskirts of town. In *Lost Boys* (Schumacher, 1987), for example, a sleepy California beach community conceals a nest of predatory vampires, and the sign welcoming you to town also welcomes you 'to Hell' in graffiti on the reverse. The original film version of *Buffy the Vampire Slayer* (Rubel Kuzui, 1992) pits an LA cheerleader against an army of the undead lurking just beneath the surface of life in the Sunshine State. And *Constantine* (Lawrence, 2005) takes the supernatural angle even further, turning Los Angeles into a literal Hell on Earth, a wasted cityscape with demons roaming the streets. Nor does the City of Angels fare any better in the future. The empty streets of LA would be Charlton Heston's idea of paradise in *The Omega Man* (Sagal, 1971); a vast concrete playground where he drives fast cars, plays with guns and listens to sleazy lounge music on an 8-track – except that those same streets are filled with desiccated corpses and he is pursued by a group of luddite cultists mutated by biological warfare. In the wake of the fires, riots, earthquakes and floods which devastated the city in the early 1990s, John Carpenter's *Escape from L.A.* (1996) offers a vision of Los Angeles as an island prison colony, cut off from the rest of America and reserved only for the most incorrigible degenerates. The definitive futuristic Hell-A, however, is surely the one in Ridley Scott's *Blade Runner* (1982). A city masked in perpetual darkness and rain, it doesn't seem to have survived an apoca-

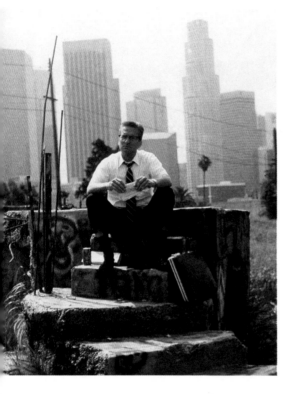

as Hell-A. The decidedly secular genre of film noir, with its failed screenwriters, desperate ingénues and conniving businessmen practically invented the concept. In these films Hollywood is an empty place, both physically and morally, echoing the assessment of Bertold Brecht, who fled Hitler's Germany to work in Hollywood, but still described Los Angeles as a hell full of 'endless trains of autos [...] in which rosy people, coming from nowhere, go nowhere, and houses, designed for happiness, standing empty.' This vacant, lonely city is the one we see in Billy Wilder's *Sunset Boulevard* (1950), a film narrated by a dead man and haunted by the ghosts of Hollywood's glory days. Most of the action takes place in the crumbling mansion of the fading silent film actress, Norma Desmond (Gloria Swanson). A mausoleum for Desmond's long-deceased celebrity, the mansion is all deep, expressionistic shadows, echoing with the moaning wind that blows through the pipe organ in the living room like the dying breaths of old Hollywood. The atmosphere of despair and humiliation is palpable, as it is in the Coen Brothers' neo-noir fantasia, *Barton Fink* (1991), in which the eponymous playwright is seduced into leaving New York for a writing job in Hollywood. Once there, he takes up residence at the down-at-heel Hotel Earle, where the only signs of other inhabitants are the neatly arranged pairs of shoes left outside the bedroom doors. Wind whips through the endless corridors and the wallpaper peels in the heat, exposing walls the moist texture of wounded flesh. This Los Angeles is all but unpopulated – barring a single scene at a USO show, Barton meets fewer than a dozen people after moving to Hollywood. By the end of the film, a third of them have been murdered, and the only one Barton might call a friend is revealed as a demoniac serial killer, and a final conflagration transforms the Hotel Earle's hellish emptiness into a literal inferno.

lypse, only to have grown so crowded and polluted that it hardly remains fit for human habitation. The skyline is dominated by the ziggurats of the Tyrell Corporation, calling to mind the pyramidal ministries of Orwell's future, and great furnaces belch flames into the sky. At ground level, things are even grimmer, with people packed together in cramped alleyways, impossibly alienated from the gleaming obsidian skyscrapers above them. In this film the city has become so dehumanizing that the people who inhabit it can no longer be sure they aren't actually androids.

But it's not only films with a supernatural or post-apocalyptic bent which see the City of Angels

**There is a devilish irony to the idea that, although from the outside Los Angeles appears to be a paradise, people on the inside are clawing at the walls to get out.**

These movies express our shared fascination with the powerful allure of Los Angeles, and the damage it can do to those who believe in its promises. Yet no matter how many times they warn us that LA is less a Garden of Eden than a latter-day Sodom or Gomorrah, we still want to believe in the paradise, and we keep turning back for one last glimpse. ✤

# LOS ANGELES LOCATIONS

## SCENES 33-39

# PULP FICTION (1994)

*Hawthorne Grill, 13763 Hawthorne Boulevard, Inglewood*

**THE DINER HAS** a long but low-key tradition in American cinema, and is a cultural touchstone from Tom Waits to Charles Bukowski. The diner in Tarantino's hymn to popular culture and low-life criminal archetypes was the Hawthorne Grill, Inglewood, which was demolished to make way for an automobile parts shop in 2001. In the timeline of the linked stories the scene sits roughly two thirds in, but the setting and events bookend the movie. Tarantino had the luxury of a vividly realised set for 'Jackrabbit Slims', where fake Hollywood icons served milkshakes to the clientele. Yet it is in this everyday American setting that we say goodbye to Jules (Samuel L. Jackson) and Vincent (John Travolta) as they saunter out having foiled – without killing anyone for once – a pair of amateur robbers-in-love (Tim Roth and Amanda Plummer) who were introduced in the pre-credit sequence. Having just announced his retirement from a life of crime to a disbelieving Vincent, Jules has to deal with his breakfast reverie being interrupted by having a gun pointed at his face. He could be an off-duty cop in the calm, paternal way he talks the youngsters down and sends them, chastened, on their way. Vincent and Jules make their exit in a fitting final shot – Jules to an uncertain future and Vincent to a fate we already know – and we bid farewell to two incongruous gangsters in ill-matching beachwear, who leave the unexceptional, workaday diner with all the iconic weight of gunslingers exiting through the swinging doors of a saloon. **↝David Bates**

*Directed by Quentin Tarantino*
*Timecode for scene: 2:07:50 – 2:23:40*
*Filming location: Jules and Vincent interrupt a hold up at a diner*

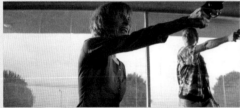
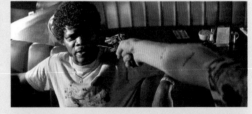

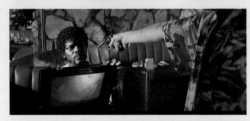
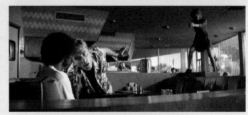

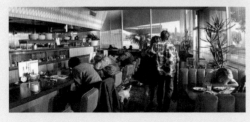

# CLUELESS (1995)

*Shoreline Village, 407 Shoreline Drive, Long Beach*

**A MODERN HIGH SCHOOL** adaptation of Jane Austen's *Emma, Clueless* is set in the moneyed heights of Beverly Hills. High-income high school students mill around in elite attire, self-segregating from the freaks, stoners and 'slackers' on the grassy knolls. After casting judgement upon them, Cher Horowitz's (Alicia Silverstone) clueless pal Tai (Brittany Murphy) has fallen for a winningly cheerful skater named Travis (Breckin Meyer). Having fallen out, Cher and Tai run into each other at Travis' amateur skateboarding event on Shoreline Drive at Long Beach. Outside the confines of school and its hierarchy of popularity, their mutual apologies are stripped of pretension, apologising profusely as they edge along the grass toward the half-pipe. Relationships are the focal point of the scene, allowing the location to lend a relaxed atmosphere. The coastal palm trees and blue skies are integral to the scene, imparting a spontaneous and unselfconscious vibe so far unseen in Cher's Los Angeles. Skaters burst onto the screen with frenetic energy, foregrounded against Long Beach Pier and the RMS Queen Mary. Its permanent mooring serves as a reminder of Tai's unseen past and, having come from informal climes, her recent attachment to the fraught LA style of keeping-up-appearances high schooling. Cher and Tai's acceptance of one another, brought together by Travis, reflect the California coast's more easygoing nature. We begin to see that Bronson Alcott High School serves as a microcosm of Los Angeles – the locals kick back as the moneyed make for the hills. As a ship can meet land, Cher finds herself finding out how the other half lives. ➥ *Nicola Balkind*

(Photo ©Shelly Borrell)

*Directed by Amy Heckerling*
**Scene description: Tai and Cher attend a classmate's skateboarding contest**
**Timecode for scene: 1:21:35 – 1:23:10**

# GET SHORTY (1995)

LOCATION *Tom Bradley Terminal (interior) and pick-up point (exterior), Los Angeles International Airport (LAX)*

**BARRY SONNENFELD'S HOLLYWOOD** gangster comedy-satire blends LA's biggest industry – movies – with one of its favourite genres – mobster mayhem. Starring John Travolta, Gene Hackman and Danny DeVito (amongst others) makes this self-aware star-studded cast one of the film's greatest assets. A handover scene takes place in Los Angeles International Airport (LAX). The dual movie-gangster motif is stamped upon the scene, which opens with Bo (Delroy Lindo) leaning against his car reading *Variety* as a plane lands overhead. The camera follows him into Tom Bradley Terminal from behind, before spinning to focus on his face. The great entrance hall melts in a blurred bricolage of people and cases behind him as Bo ensures everything is under control. Meanwhile, Bear (James Gandolfini) selects his luggage from the carousel and makes his way outside. A swooping camera follows him to the Tom Bradley arrivals pick-up point and into a black limousine – another symbol of Los Angeles' overt celebrity culture – to continue his journey on to the City of Angels, gangsters and movie demons. Taken alone, this scene reveals a quick link to the industry, following genre convention faultlessly. What comes to be revealed is that even LAX is a set on a movie studio lot: another elaborate ruse, and another product of the business we call show. ↝*Nicola Balkind*

*Directed by Barry Sonnenfeld*
**Scene description: Bo Catlett plants key to safe on young kid in terminal**
**Timecode for scene: 0:21:30 – 0:24:45**

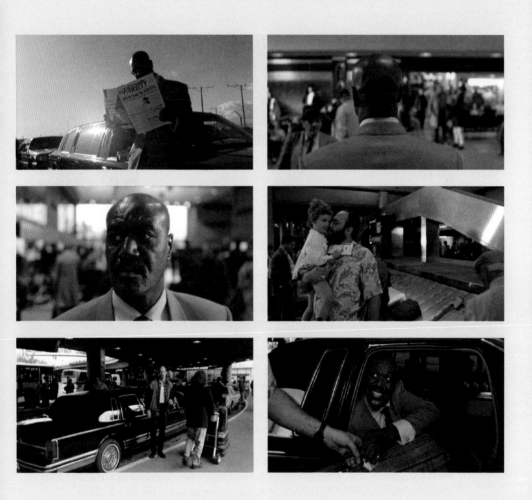

Images ©1995 Mgm/Jersey Films

# HEAT (1995)

LOCATION

*Far East Bank, 350 South Grand Avenue (interiors) and 444 South Flower Street at 5th Street (exteriors), Downtown*

**SET AND SHOT** at both the Far East Bank at 350 South Grand Avenue (for interior shots) and the exit outside the 444 Building, at 444 South Flower Street (gang exiting the bank), the bank robbery is the centrepiece of Michael Mann's masterpiece and, as in the fabled heist sequence in *Rififi* (Dassin, 1955), the astonishing slickness of the film-making mirrors the astonishing slickness of the criminals' operation. The music – a driving, repetitious sound like the countdown to an alarm – signals the start of the scene. Robert De Niro's Neil McCauley enters the bank. Like his two colleagues, he is well-dressed and inconspicuous. The slow motion Mann employs shows that, for McCauley, everything is calm. For the bank's employees and customers what follows will be chaos. For McCauley it will happen as if in slow motion, as great sporting moments are said to for great athletes, and as combat is said to for great soldiers. McCauley strides onto a desk, a balaclava now obscuring his face and an automatic rifle announcing the penalty for disobedience. Still, he is calm. As customers cower, he assures them, 'We want to hurt no one. We're here for the bank's money, not your money.' The vault is unlocked and emptied with mechanical precision; the smoothness of the bank's marble and the polished steel of the vault reinforcing the smoothness of the crime. But *Heat* is a heist movie, and heists in film must go wrong. As they leave the bank laden with cash, McCauley's accomplice (Val Kilmer) spots the police officers who intend to apprehend them. He raises his rifle and, at last, true chaos erupts. **•❥Scott Jordan Harris**

*Directed by Michael Mann*
Scene description: Robbery at the Far East Bank
Timecode for scene: 1:37:32 – 1:43:40

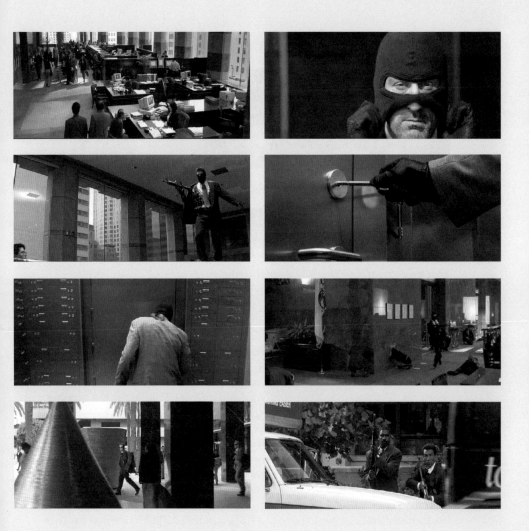

# SWINGERS (1996)

LOCATION *The Derby, 4500 Los Feliz Boulevard and corner of Hillhurst Avenue*

**JON FAVREAU** and Doug Liman's breakout 'bromance' *Swingers* is often remembered for the road trip the boys take to Vegas; but its story of a group of aspiring actors united by their professional and romantic failures is pure Los Angeles. The film is a journey through historic LA nightspots as Michael (Favreau) attempts to get over a breakup. Although the characters frequent many of the landmarks in the affluent North Hollywood neighbourhood of Los Feliz, the emotional payoff occurs at The Derby, a nightclub at the forefront of the '90s swing revival chronicled by *Swingers*. The trip to see Big Bad Voodoo Daddy at The Derby is a turning point for Michael. After the constant rejections and failures he's suffered earlier in the film, now he swaggers into the club, followed into the back door, through the kitchen and to a reserved table by an extended tracking shot which recalls an earlier conversation about Scorsese's *Goodfellas* (1990). To the soundtrack of a jumpy swing rendition of 'You and Me (And the Bottle Makes Three)', the boys take their seats and are immediately surrounded by women. Amid the plush decor of The Derby, Michael and his friends finally seem to be living the glamorous Old Hollywood lifestyle they've been imitating throughout the rest of the film. In a scene which evokes the spirit of the whole swing revival, *Swingers* switches register for a moment of musical storytelling worthy of Fred Astaire or Gene Kelly, and before he leaves the club, Michael's awkwardness evaporates in a scintillating dance with fellow heartbroken LA newcomer, Lorraine (Heather Graham). ••*Martin Zeller-Jacques*

*Directed by Doug Liman*
**Scene description: Big Bad Voodoo Daddy at the Derby**
Timecode for scene: 1:08:27 – 1:19:00

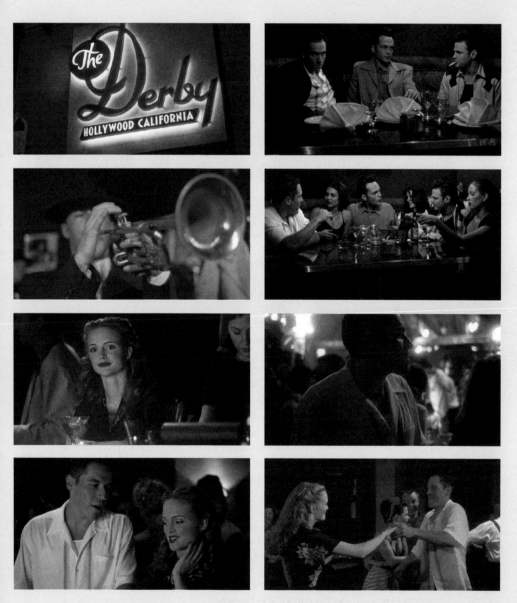

# L.A. CONFIDENTIAL (1997)

LOCATION *The Formosa Café, 7156 Santa Monica Boulevard, West Hollywood*

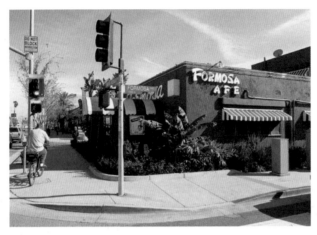

**THE THREE MAIN PROTAGONISTS** in Curtis Hanson's film are flawed men negotiating and fighting for advantage in roles unfamiliar to them. Jack Vincennes (Kevin Spacey) is a corrupt cop punished by demotion from his favoured showbiz beat, where his easy charm and flexible moral boundaries allow him access and influence in a seemingly glamorous world. Ed Exley (Guy Pearce) longs for the alpha-male confidence embodied in the absent Bud White (Russell Crowe), whilst despising the rule-breaking machismo he exhibits. They enter the real-world location of The Formosa Café in West Hollywood, where they confront actress Lana Turner and her real-life boyfriend Johnny Stompanato. Still open today, the Formosa Café has a long history of entertaining Hollywood stars and other movie and show-business figures. Even though reluctantly engaging in his new role of vice squad detective, Vincennes is instantly at ease on entering the Café. In contrast, the insecure Exley overplays his role as tough-guy investigator and manages to insult Lana Turner by mistaking her for a prostitute, one of a group who have undergone plastic surgery to resemble famous actresses of the day. Vincennes is amused by his partner's error and the drink thrown in Exley's face by the outraged star. Nonetheless, the scene is one of bonding between the two men when, outside, Exley displays rare self-awareness when he laughs at his own ineptitude in his role. The Café is a fitting setting in a story where the famous are as much part of the location as the buildings. **David Bates**

**Scene description: Exley and Vincennes confront Johnny Stompanato and Lana Turner**

Timecode for scene: 1:27:00 – 1:27:48

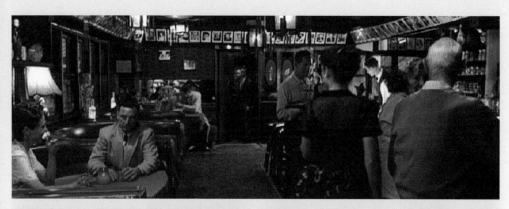

 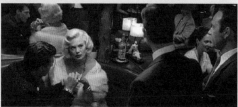

# BOOGIE NIGHTS (1997)

LOCATION  *Iglesia De Restauracion, 18419 Sherman Way at Canby Avenue, Reseda*

**PAUL THOMAS ANDERSON'S** story, set in the 1970's adult film industry of the San Fernando valley in Los Angeles, establishes it's milieu with a shot of the now-closed Reseda Picture House. The title of the film is displayed as if it is playing at the picture house (it isn't made clear whether this is meant to be an adult movie theatre), we then take in the neon sign for the picture house before the camera whips round to follow a car down the street as it pulls up to, and into, the Hot Traxx nightclub in a three-minute tracking shot. For all that this scene owes to Scorsese and his own adoring tracking shots of New York or Vegas gangsters at play, Anderson instead has fun with the tacky fashions of the decade and the slightly grubby exteriors of both the cinema and the nightclub. The brief glimpse of street life makes it clear that this is not a high-rent area, despite the aspirations of the characters to the glamour that the disco era offered. The tawdry reality of the everyday work of the protagonists who are introduced as we enter the nightclub is offset by the evident affection of Anderson for his characters, and his refusal to judge them. The glamour and disco lights might be fake and ephemeral, but we do not begrudge these players their pretensions to a more exciting life. There is a playful innocence in their interactions, despite the dark moments to come. ❖*David Bates*

*Directed by Paul Thomas Anderson*
**Scene description: The swirling opening shot sets the stage**
**Timecode for scene: 0:00:55 – 0:07:50**

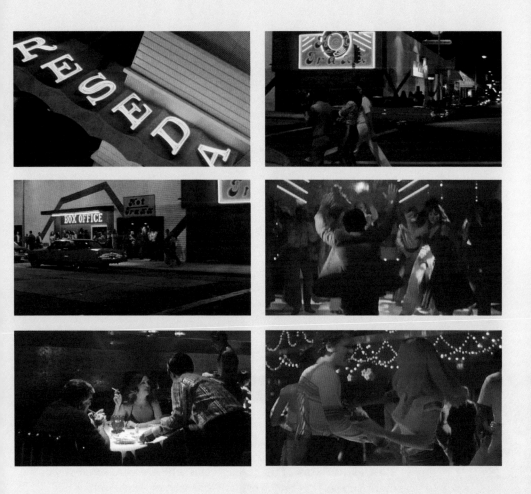

# LIVING IN A MANN'S WORLD

*Michael Mann's Los Angeles*

Text by
WAEL
KHAIRY

**MICHAEL MANN** probably understands the interdisciplinary field of environmental psychology better than any working director. He recognizes the close interplay between people and their surroundings and is fully aware that factors in the environment have an effect on behaviour, psyche and identity, and he often exploits these ideas in his films. *Miami Vice*, Mann's 2006 crime drama, is as much about the city as it is about the narrative and the characters on-screen. The same can be said about Chicago's portrayal in *Thief* (1981) and *Public Enemies* (2009), but it is the director's visual representation of Los Angeles that speaks volumes about his perceptive understanding of time and space. Closed spaces and their interiors have

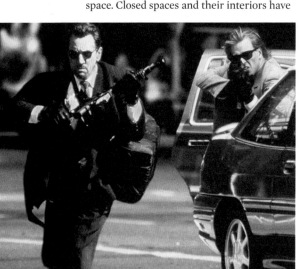

a direct impact on our brains, and Mann uses the visual medium of film as a dynamic tool to express this. He manages to pull it off on a much larger scale by taking advantage of a city's emotional impact on the viewer to express the heart of the story being told and the characters that populate it.

Michael Mann's career reached a peak with the 1995 crime epic, *Heat* – a more complete and polished version of his TV movie *L.A. Takedown* (1989) – considered by the director as an early 'rough draft'. Many have described *Heat* as the single greatest Los Angeles crime epic ever made. It is hard to argue otherwise for Mann managed to achieve what so many had tried and failed to do previously. Instead of filming Los Angeles as the backdrop of events unfolding on the screen, he merges the city with its inhabitants and puts both in the foreground. The lonely male protagonists in *Heat* wander within the emptiness of an alienated land.

Los Angeles is an overpopulated city, yet it is depicted as a silent milieu of isolation. Mann provides us with a canvas of the great city, only one we've never laid eyes on before. A car driving on an empty highway, flickering city lights of a silent night, an empty apartment reflecting an endless ocean, airport runway lights fading to complete darkness; it's all there to inject the viewer with a mood similar to that felt by the characters throughout this tragic journey.

Visually, *Heat* is treated like a film noir and so we wind up with a neo-noir. The conventions and elements of that genre are

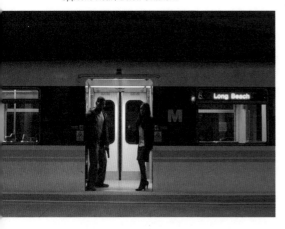

As in *Heat*, the two main protagonists in *Collateral* are loners desperately trying to find their place in a city that has turned its back on its people. Mann uses wide night-shots of the flickering lights of an endless cityscape. Cars isolated from the rest of the world flow through the freeways in silence. One of the cars driving through Los Angeles in this darkened netherworld is the taxi containing our cab driver protagonist and hitman antagonist. Mann shot all of the exterior scenes using digital video because he believed DV reacted much better to low-key lighting than film stock, the result of which is a look both unique and unfamiliar.

The parallels with *Heat* are both textual and visual. Textual in the sense that Vincent (Tom Cruise) recalls the detached efficiency of Neil McCauley, and when they talk about their history, it becomes clear that both share a similar childhood. McCauley ends with, 'I got a brother somewhere.' In terms of visuals, they both journey through the streets of Los Angeles dedicated to what they do best. They also share the same cinematic fate since both meet their demise at locations of transport or 'non-places', one at LAX and the other on an elevated metro train.

That is not to say Mann had nothing new to say about Los Angeles. Through his alternative vision we see the real politics and sociological aspects of LA on-screen. Instead of showcasing the hot summer beaches, we drive past black neighbourhoods, Latino shops and Korean nightclubs at night. Watching *Heat* or *Collateral* is as close as one could get to actually being there because the viewer experiences a distinct melancholy beauty of the city through Mann's signature stylistic approach. The nature of both films is different, but the look and feel of the city corresponds because Los Angeles has the same isolating effect on both sets of characters. One thing is for sure, film fans from all over the world will now make a tourist spot of the Fever jazz club featured in *Collateral* as they did with the Kate Mantilini restaurant – the Beverly Hills location used for De Niro and Pacino's famed coffee shop confrontation in *Heat*.

Michael Mann will go back to his TV roots for his next venture into Los Angeles in the forthvoming HBO series *Luck*. ✦

crystal evidenced by the hardboiled detective and urban setting, the interplay of light and shadow in the final scene and the neon lights of the dark corners of an urban city. However, there's certain uniqueness to the atmosphere and mood of the film due to the icy blue palette apparent in the atmospheric tone. The director used many paintings as inspiration for the look of the film, most notably for the shot of Neil McCauley (Robert De Niro) in his apartment facing an open ocean with a gun on the table – an image which is almost identical to Alex Colville's 1967 painting 'Pacific'.

Mann has said:

'I love Los Angeles. Eighty per cent of it is unexplored. People who make films don't go out into the city. They think they do but they don't. You just drive down the right streets and you'll see images of alienation. But they are beautiful images of alienation. They become paradoxical but they present themselves to you.'

While *Heat* is Mann's quintessential Los Angeles film, *Collateral* (2004) is his exploration of the city's darker side. In many ways both films serve as extensions to the environment and impression of an everyday city like Los Angeles.

**Closed spaces and their interiors have a direct impact on our brains, and Mann uses the visual medium of film as a dynamic tool to express this.**

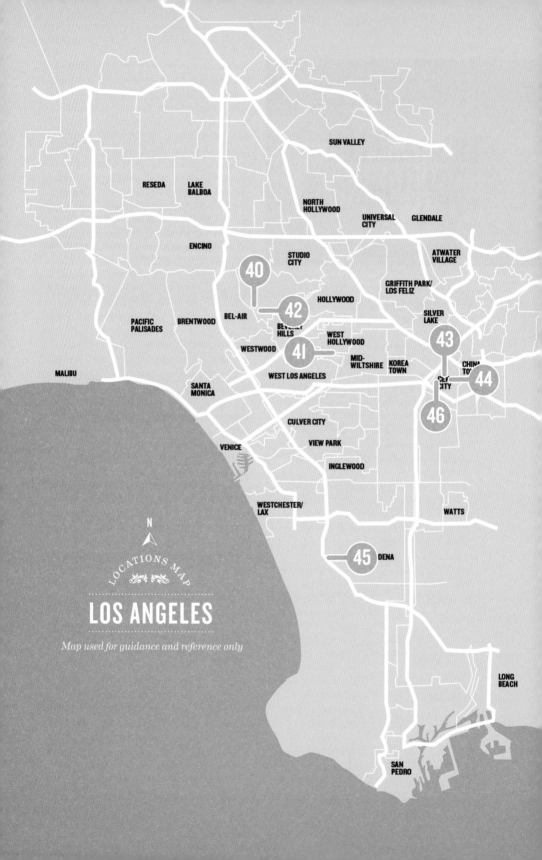

SUN VALLEY

RESEDA

LAKE
BALBOA

NORTH
HOLLYWOOD

UNIVERSAL
CITY

GLENDALE

ENCINO

STUDIO
CITY

ATWATER
VILLAGE

40

HOLLYWOOD

GRIFFITH PARK/
LOS FELIZ

BEL-AIR

42

SILVER
LAKE

PACIFIC
PALISADES

BRENTWOOD

BEVERLY
HILLS

WEST
HOLLYWOOD

43

WESTWOOD

41

MID-
WILTSHIRE

KOREA
TOWN

CHINA
TOWN

MALIBU

WEST LOS ANGELES

CE
CITY

44

SANTA
MONICA

46

CULVER CITY

VENICE

VIEW PARK

INGLEWOOD

WESTCHESTER/
LAX

WATTS

N

45

DENA

LOCATIONS MAP

LOS ANGELES

Map used for guidance and reference only

LONG
BEACH

SAN
PEDRO

# LOS ANGELES LOCATIONS

## SCENES 40-46

# THE SLUMS OF BEVERLY HILLS (1998)

*10050 Cielo Drive, Benedict Canyon*

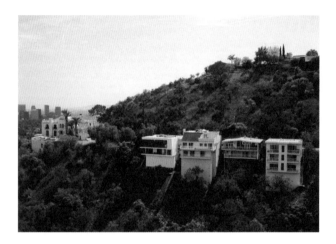

**DEVELOPED AT** the Sundance Institute and executive produced by Robert Redford, Tamara Jenkin's semi-autobiographical coming-of-age debut focuses on Viv Abromowitz (Natasha Lyonne); a mouthy, motherless teenager experiencing a sexual awakening in the mid-1970s. Her family's lower-middle-class income keeps them in the Beverly Hills school district, but also sees them on the move from one ratty apartment to the next as dad Murray (Alan Arkin) skips out on paying the rent. Viv must look after her rehab-fleeing cousin Rita (Marisa Tomei), and try to discern what to do about her fledgling interest, the Manson Murder obsessive Eliot (Kevin Corrigan). The infamous Tate House makes its appearance when Viv and Eliot drop Rita off to see her boyfriend from rehab. Eliot ineptly manoeuvres to get closer to Viv by regaling her with the house's macabre history (in 1969 Charles Manson's 'family' of followers murdered four people at the residence, including Roman Polanski's wife, actress Sharon Tate). Rather than creeping out the audience, Jenkin's inclusion of the Tate House is used for comedic effect, and reflects the ongoing pre-occupations of the era as tribes and teens attempt to radically demonstrate their outsider status. The Tate House was located at 10050 Cielo Drive in Benedict Canyon. Tourists could glimpse the property from the top of Bella Drive (a publicly accessible street). However, the house was demolished in 1994 and a new property called Villa Bella was erected.
⇢**Deirdre Devers**

**Above** Stilt houses along the private road leading to 10050 Cielo Drive (Photo ©Dave McGowan)

*Directed by Tamara Jenkins*
**Scene description: Viv and Eliot wait for Rita to return**
**Timecode for scene: 0:55:05 – 0:56:04**

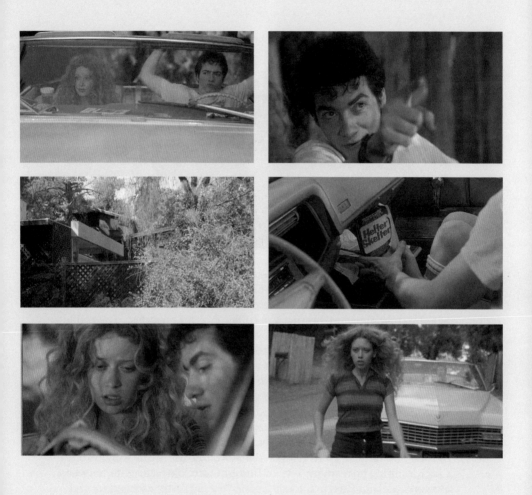

# AMERICAN HISTORY X (1998)

*Johnie's Coffee Shop, 6101 Wilshire Boulevard, corner of Fairfax Avenue*

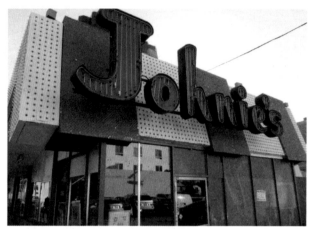

**HAVING ANGERED** his former friends in the local white supremacist movement, and virtually everyone else by his involvement with it, reformed racist Derek Vinyard (Edward Norton) has to literally look over his shoulder when he takes his little brother to a coffee shop for breakfast. The coffee shop in question is Johnie's on Wilshire Boulevard. Now closed, but still standing, it is one of LA's 'Googie' coffee houses, designed during America's mid-twentieth century fascination with the space age, and clearly displaying its influence. With its old-style signage, diner-style seats and newspapers for sale outside, the shop seems impossibly peaceful and all-American – and, as such, is the ideal setting for a scene about an eruption of racial violence that threatens to shatter LA society. As Derek places his order, his former high school principal – who is teaching Derek's brother the one-on-one 'American History X' class of the film's title – enters with a high-ranking policeman. Two of Derek's erstwhile colleagues have been attacked and admitted to intensive care. Fearing further violence – and perhaps riots – will follow, the policeman and the principal ask Derek to appeal to the local neo-Nazis, and ask them to resist retaliation. Eventually, reluctantly, he agrees – but adds, 'You're gonna get me shot by a bunch of white boys.' The tension is intense; the tragedy is seemingly inevitable. Even here, in the most calm and comforting of surroundings, Derek is hunted – and our renewed fears for his safety add an astonishing potency to the film's sudden and surprising conclusion. **•Scott Jordan Harris**

Scene description: Conference at Johnie's Coffee Shop
Timecode for scene: 1:41:58 – 1:44:49

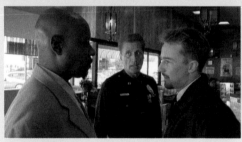 

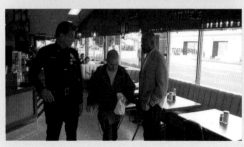 

Images ©1998 New Line

# THE BIG LEBOWSKI (1998)

*The Sheats-Goldstein residence, 10104 Angelo View Drive, Benedict Canyon, Hollywood Hills*

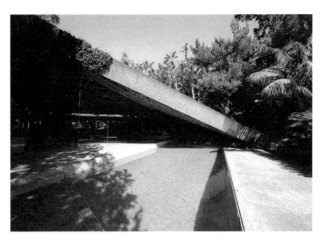

**THE USE OF MALIBU** as the setting for this confrontation between the pornographer Jackie Treehorn (Ben Gazzara) and The Dude (Jeff Bridges) (and as a result, the anger of the police chief seeing a drugged up Dude causing havoc around this 'nice, quiet little beach community') is significant for several reasons. Malibu is situated just north of the main urban sprawl that makes up the city of Los Angeles, and is well known for it's beautiful beaches and surrounding countryside. It is also known as a place where the rich and famous dwell (especially movie stars). This, therefore, is not the kind of place that The Dude would often frequent and is far removed from his regular hangout in the comparatively seedier Venice Beach. This is exacerbated in the opening of the scene, filmed on location at Point Dume on Malibu Beach, where we see the beach party in full swing with topless girls being gracefully tossed up into the air set to some very asserting and somehow unsettling music ('Atypura' by Peruvian soprano singer Yma Sumac). Treehorn then makes his ethereal entrance and walks right up to the camera (the subjective view point of The Dude) and welcomes him (us). He proceeds to lead The Dude into his house and it's at this point that, in reality, we leave Malibu. The house used for the remainder of the scene is actually the Sheats-Goldstein Residence located in the hills high above Beverly Hills. Designed by the famous architect John Lautner, the house's futuristic décor and use of space are fine examples of his work and adds to the bizarre set of circumstances that The Dude finds himself in. **Toby King**

(Photo ©Marc Audap)

Scene description: Inside pornographer Jackie Treehorn stylish Malibu beach home
Timecode for scene: 1:11:40 – 1:16:55

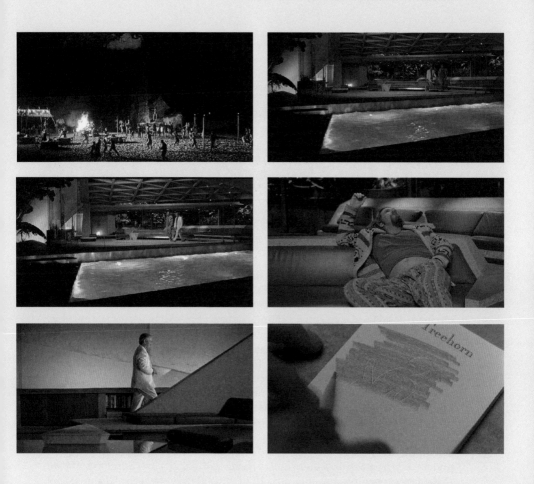

# THE MILLION DOLLAR HOTEL (2000)

LOCATION *Rosslyn Million Dollar Fireproof Hotel (Currently Rosslyn Lofts), 451 South Main Street, Downtown*

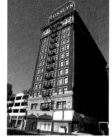

**WIM WENDERS'** *The Million Dollar Hotel* opens with a helicopter shot of Los Angeles paired with a subdued U2 ballad, 'The First Time'. (U2's Bono both conceived the story and produced the film). The camera circles around the Downtown skyline, set against a bluish early evening sky, before travelling a few blocks northward, to the central location of the film: the Rosslyn Million Dollar Hotel. The film's location has seen periods of both prosperity and poverty. The Million Dollar Hotel opened in the 1910s as one of the city's premiere hotels. Wenders' film captures the location at a much different time in the history of Downtown Los Angeles, when this area (now known as the Old Bank District) was no longer a central location for business or culture. In *Million Dollar Hotel*, the location serves as a flophouse for the uninsured and mentally ill. In the last decade, however, the location – recently converted into luxury lofts – is one of more than ten redevelopment projects undertaken as a result of an adaptive re-use ordinance passed in 1999. *Million Dollar Hotel*'s opening shot ends up behind the hotel's lighted sign. The next shot tracks the film's lead, played by Jeremy Davies, walking anxiously across the rooftop. Tom Tom, who (we will later learn) pushed a friend to his death from the same location, pauses on one side of the roof. He sprints, in slow motion, across the rooftop. The scaffold sign of the Million Dollar Hotel and the surrounding skyline of Downtown Los Angeles remain visible through his fateful run. Recalling Hitchcock's *Rear Window* (1954), after he jumps, a slow motion, first-person point-of-view shot captures a handful of mini-dramas in the cross-street apartment windows as we move toward the ground. **✦Jesse Schlotterbeck**

(Photos ©Damian Gadal)

*Directed by Wim Wenders*
*Timecode for scene: 0:01:00 – 0:05:00*
*Filming location: Tom Tom leaps from the top of the Million Dollar Hotel*

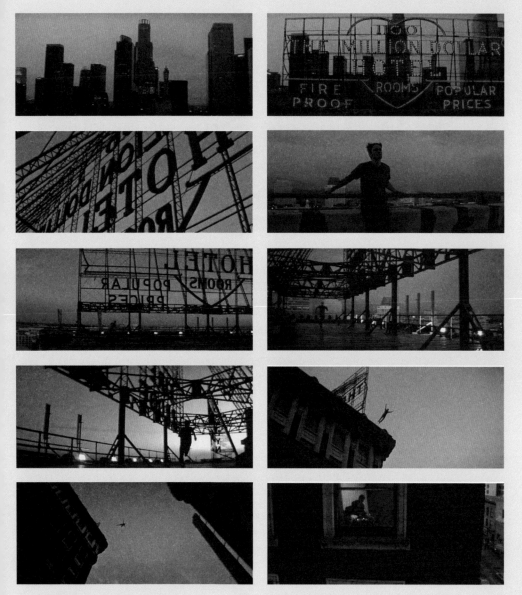

Images ©2000 Icon/Kintop/Road Movies

# MULHOLLAND DRIVE (2001)

*Barclay Hotel, 103 West 4th Street, Downtown*

**DAVID LYNCH** has often said that *Sunset Boulevard* is among his favourite films. Hence, it's no surprise that *Mulholland Drive* draws much eerie inspiration from Billy Wilder's 1950 classic. Not only do both films offer a critique of people who are ultimately destroyed by the film industry, but also the action starts with an incident involving a car accident. In *Mulholland Drive*, Rita (Laura Elena Harring) narrowly escapes an attempt on her life inside a limousine when the limo is hit by joyriders. She escapes from the wreckage with an absurd amount of cash, amnesia and the uneasy feeling of being pursued. Rita's right to feel uneasy. The Barclay Hotel plays host to one of *Mulholland Drive*'s most blackly comical scenes, in which hitman Joe (Mark Pellegrino) is on the hunt for a 'black book' that could bring him closer to his target, Rita. Joe shoots the breeze with Ed (Vincent Castellanos), only to shoot him in the head. Joe places the gun in his victim's hand to make it seem like a suicide attempt – only the gun goes off to strike the occupant in the room next door. The Barclay Hotel sits on the edge of skid row in Downtown Los Angeles (4th and Main). A favourite film shooting location, in *Mulholland Drive* Lynch uses the building's tawdriness to brilliant effect as Joe battles an obese woman, janitor, vacuum cleaner and small electrical fire to procure the precious black book. ⇢ *Deirdre Devers*

*Directed by David Lynch*

**Scene description: Joe struggles to get hold of the 'black book'**
**Timecode for scene: 0:34:43 – 0:39:04**

Images ©2001 Studio Canal+/Les Films Alain Sarde/Universal

# COLLATERAL (2004)

*Redondo Beach Station of the Los Angeles County Metro's Green Line*

**MICHAEL MANN'S** crime thriller follows the lengths a contract killer (Tom Cruise) will go to eliminate the witnesses in prosecutor Annie Farrell's (Jada Pinkett Smith) case during a single night. Passive cab driver Max (Jamie Foxx) is shanghaied into being Vincent's driver, not anticipating the body count or that his previous passenger, Annie, is also on Vincent's hit list. Max guides Annie through the 7th Street and Figueroa Street entrance to an austere subway system devoid of connection (and some might say is as alienating as the cars it offers an alternative to). Mann deftly directs us through the nighttime streets of Los Angeles finally free of traffic. But like Jan de Bont's *Speed* (1994), Mann takes the action underground and uses the Los Angeles Metro to stage Vincent's relentless pursuit of Max and Annie during the final act. The Metro, a descendent of the Pacific Electric rail lines from the 1950s, opened in 1990 and consists of 70 stations and a network of five colour-coded lines. Playing somewhat loosely with actual trainline orientation, Vincent corners Annie and Max on the Blue Line that runs from the Financial District to Long Beach and which then supposedly heads south but is actually a Green Line train, heading west, stopping briefly at Harbor Freeway Station. Max and Annie finally leave Vincent behind at Redondo Beach Station – the same station incidentally at which Mann's *Heat* opens. This is Mann's first feature shot almost entirely with high-definition cameras, which starkly captures the impersonality of Los Angeles. It is an impersonality that is not only rendered beautifully, but casts an eye upon a side of Los Angeles not frequently seen. **↝Deirdre Devers**

(Photos ©Sean Lamb)

*Directed by Michael Mann*
**Scene description: Showdown on the MTA to Redondo Beach**
**Timecode for scene: 1:41:34 – 1:46:48**

# IN SEARCH OF A MIDNIGHT KISS (2007)

*Orpheum Theatre, 842 South Broadway, Downtown*

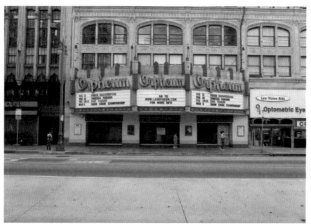

**THE SEARCH FOR A MIDNIGHT KISS** on New Year's Eve is the catalyst for Alex Holdridge's funny, touching and sharp take on romance and dating. Partly a story about love, and partly a love letter to Los Angeles, *In Search of a Midnight Kiss* is a beguiling blend of classic and contemporary cinema styles and timeless themes that is perhaps the quintessential modern cinematic vision of the city. The script grew out of the director's wanderings around Downtown LA with actress Sara Simmonds, who plays Vivian to Scoot McNairy's Wilson. The monochrome photography lovingly captures the street life, landmarks, beauty and faded grandeur of the city within which the meandering blind daters discuss their lives, relationships and aspirations. Whilst wandering through the Broadway Theatre District, the pair talk their way into the empty Orpheum Theatre. Part of the area's collection of pre-World War II cinemas, the Orpheum visually symbolises the city's history and its changing cultural patterns, and, narratively, Wilson and Vivian's reasons for moving to the City of Angels. Wilson, a wannabe scriptwriter, and Vivian, with her dreams of becoming an actress, are awestruck, inspired and touched by the theatre's grand architecture, cavernous space and historic importance. With the majority of the surrounding theatre's closed and in disrepair, in reality the 'abandoned' Orpheum has undergone major renovation work and re-opened on numerous occasions since it first opened its doors in 1926. LA resident but Texas born, Holdridge's visual paean to his adopted city is never better encapsulated than in this beautifully simple and evocative sequence. **•❖ Neil Mitchell**

*Directed by Alex Holdridge*
*Scene description: Wilson and Vivian explore the Orpheum Theatre*
*Timecode for scene: 0:31:15 – 0:36:00*

# EUROVISIONS

*Alternative Views of the Hollywood Landscape*

Text by
MICHAEL
S DUFFY

**EUROPEAN DIRECTORS** have a long history of being courted by Hollywood; they were often able to conjure artistically valuable cinematic artifacts and graft a unique visual style onto familiar genres and formulas, extrapolating hidden, complex messages lying just beneath the showy surface of Los Angeles. German Expressionists like Fritz Lang were able to mask their creative distinctions within the assembly line production process, but could be impressionistic in the way they tackled Hollywood iconography with unusual angles and aesthetic choices. The French New Wave encouraged directors not only to experiment with their native cinema, but meddle with America's as well; and most fascinatingly, Italian auteurs like Michelangelo Antonioni were more interested in the landscape of Los Angeles – the signs, subtexts, and ambiguous, sometimes ambivalent feelings generated when "urban renewal" was juxtaposed with free-range thoughts in the open desert.

In the 1930s, many prominent German filmmakers fled to Los Angeles to escape the increasingly stultifying regime in their own country. Fritz Lang worked in a variety of

Hollywood genres, but became best known in America for the subtle stylistic touch and efficiency he brought to the movement later known as film noir. *The Blue Gardenia* (1953), Lang's first film set explicitly in Los Angeles, managed to combine murder, blonde doppelgangers, and sensationalist journalism with an appearance by Nat King Cole! Max Ophuls' stay in Hollywood was very brief, but he demonstrated with *Caught* (1949) that one could aesthetically innovate within low budget filmmaking, incorporating frequent use of expressive long takes and fluid camera movement through the use of a relatively new "crab dolly" setup. "Moving pictures should move," he once said.

Jacques Demy's *Model Shop* (1969) brought a contemporary French aesthetic to a city in transition. Demy's film is devoid of action or spectacle, but rich in characterized desolation stemming from the post-urban renewal wasteland of Los Angeles. The film pairs up American actor Gary Lockwood with French star Anouk Aimee, reprising her character from Demy's more widely-recognized *Lola* (1961). There is a constant sense of disconnect between the film's two lead characters and the director's take on the fractured city he is filming. When Lockwood's character loses his convertible and is shipped off to Vietnam, he leaves his money for Lola, so that she may return to France. One could read the film as a cautionary message to future foreign directors trying their hand in Hollywood: meaningful significance may be possible, but it's fleeting and not without consequences. Jacques Deray's *The Outside Man* (1972) transplants a French hit-man (Jean Louis Trintignant) to Los Angeles; he finds himself the target of another assassin – and the gap in language and culture only make the task of surviving more difficult. *The Outside Man* is

more blatant in its message than *Model Shop*; L.A. here serves as an aggregate of violence, misunderstanding, confusion and despair – in some international territories, the film was released under the title *Funeral in Los Angeles*! Though helmed by American director Steven Soderbergh, *The Limey* (1999) offers a compelling contemporary parallel to Deray's *Outside Man* – it's a generational call-back to the L.A. of the 1960s and 70s with Terence Stamp and Peter Fonda. Stamp's English-born and bred ex-criminal Wilson arrives in the city of angels (with dirty faces) looking for clues to the death of his daughter; the Hollywood Hills gain grim, menacing new meaning, and oceanfront property of the Big Sur has never seemed so constrictive or corrupt.

"Getting back to the land" was also one of the prevailing themes of films set in Los Angeles during the 1960s and 70s, constituting a complex reaction to "urban renewal" throughout the industrial and cultural atmospheres of American media and society. Italian director Michelangelo Antonioni only shot one motion picture in America, but *Zabriskie Point* (1970) has plenty of things to say about cinema and urban modernity despite its historically mixed reputation. The

**European directors have consistently offered a distinctive look at the ups and downs of Los Angeles as both a city of movement and a place of potential – and potential heartbreak.**

film's numerous zoom-ins on manufactured farmland billboards and avant-garde soundtrack, which mixes industrial noises, audio effects and instruments, all comment on the increasing difficulties of maintaining a balance between where we come from and where we're going. Elsewhere in Antonioni's L.A. thesis, an advertising agency reviews a proposal for "Sunny Dunes Land Development Company," which promises to provide a return to old-fashioned luxury and suburban comfort, but with plastic chairs and cookie-cutter house plans. The scene satirizes the rapid industrial and land expansion in California, emphasizing the loss of naturalistic ideals as contemporary urban lifestyles take over. As the film cuts abruptly to a car moving through a busy multi-lane sprawl, a radio reporter discusses a new freeway connecting the "central Los Angeles area" to the "foothills" at the expense of 50,000 residents along the way, highlighting – for those who haven't yet tuned out – the increasingly fragmented connection between natural landscapes and densely populated modernity. In numerous intricate ways, *Zabriskie Point* shows that international filmmakers can often find creative ways of commenting on contemporary American culture, and in this case the changing nature of the city of Los Angeles itself.

These days, European filmmakers are still capable of carving unique marks onto the cinematic landscape of Los Angeles: Wim Wenders' *The Million Dollar Hotel* (2001) could be his answer to Hollywood's *City of Angels* (a loose refit of Wenders' *Wings of Desire*), offering Mel Gibson as a disturbed detective with a shattered spine and Jeremy Davies and Milla Jovovich as a pair of unthreaded loners who find each other in a broken-down and destitute building which reflects its real-life state at the time of filming.

European directors have consistently offered a distinctive look at the ups and downs of Los Angeles as both a city of movement and a place of potential – and potential heartbreak. Envisioning an American landscape different from what Hollywood normally presents to us, these unique artists arguably prove that the most valuable films are often those that embrace the complications and contradictions inherent in a so-called civilized society. ✦

# GO FURTHER

*Recommended reading, useful websites and further viewing*

## BOOKS

**Los Angeles:**
**A City On Film**
Curated by Thom Andersen
(Vienna International Film Festival, 2008)

**Silent Echoes:**
**Discovering Early Hollywood Through**
**the Films of Buster Keaton**
By John Bengston
(Independent Publishers Group, 1999)

**Silent Traces:**
**Discovering Early Hollywood Through**
**the Films of Charlie Chaplin**
By John Bengston
(Santa Monica Press, 2006)

**Location Filming in Los Angeles**
By Karie Bible, Marc Wanamaker and
Harry Medved
(Arcadia Publishing, 2010)

**Hollywood Escapes:**
**The Moviegoer's Guide to Exploring**
**Southern California's Great Outdoors**
By Harry Medved with Bruce Akiyama
(St. Martin's Griffin, 2006)

**Michael Mann**
By F.X. Feeney Edited by Paul Duncan
(Taschen, 2006)

**Los Angeles, Portrait of a City**
By Kevin Starr, David L. Ulin and Jim
Heimann
(Taschen, 2009)

**Nobody's Perfect: Billy Wilder:**
**A Personal Biography**
By Charlotte Chandler
(Applause Theatre Book Publishers, 2004)

## BOOKS (continued)

**L.A. Noir: The City as Character**
By Alain Silver and James Ursini
(Santa Monica Press, 2006)

**The Cinematic City**
Edited by David B. Clarke
(Routledge, 1997)

**Somewhere in the Night:**
**Film Noir and the American City**
By Nicholas Christopher
(Shoemaker & Hoard, 2006)

**Film Noir (Inside Film)**
By Andrew Spicer
(Longman, 2002)

**Silent Echoes: Discovering Early Hollywood**
**Through the Films of Buster Keaton**
By John Bengston
(Independent Publishers Group, 1999)

**City of Quartz**
By Mike Davis
(London: Pimlico, 1998)

**John Boorman**
By Michel Ciment
(London: Faber and Faber, 1986)

## FILMS

**Los Angeles Plays Itself**
Directed by Thom Andersen
US, 2003, colour, 169 min.

**Los Angeles Now**
Directed by Phillip Rodriguez
US, 2004, colour, 60 min.

**L.A.X.**
Directed by Fabrice Ziolkowski
US, 1980, b/w, 88 min.

# CONTRIBUTORS

*Editor and contributing writer biographies*

## EDITOR

**GABRIEL SOLOMONS** is the founder and senior editor of *The Big Picture* film magazine and group editor of the *World Film Locations* book series. He is a senior lecturer on graphic design at the University of the West of England, Bristol and design innovator at Intellect.

## CONTRIBUTORS

**NICOLA BALKIND** is a freelance film journalist and web content producer based in Glasgow, Scotland. She holds a BA (Hons) in Film and Media Studies, and is currently writing her MLitt in Film Journalism at the University of Glasgow. As well as contributing to *The Big Picture* magazine and regional press, her thesis on anthropomorphism in animation entitled *Animation and Automation* was recently published by Film International. Nicola is also Web Editor of the Channel 4 branded website *Quotables* (powered by Mint Digital), and Web Editor of Edinburgh International Film Festival. You can find Nicola online at *nicolabalkind.com*.

**DAVID OWAIN BATES** spent his childhood on a Carmarthenshire farm, has looked after children with learning disabilities in Bristol, worked as a chef in a Chinese restaurant in West Wales and run a pub in South London. He has worked in a dot-com company at the height of the boom, where he drank a lot of the venture capitalists money in the finest bars in Soho and lost his job in the crash. He has been involved in an international charity start-up and solved more computer problems and server crashes than he can recall. One day he will decide what he wants to do when he grows up but until then is dealing with an addiction to DVD box sets and a love of the darkened dream world of the cinema, where he mutters darkly about safety lights ruining the magic. He wants to live in the Everyman in Hampstead.

**JEZ CONOLLY** holds an MA in Film Studies and European Cinema from the University of the West of England, and is a regular contributor to *The Big Picture* magazine and website. Jez comes from a cinema family; his father was an over-worked cinema manager, his mother an ice-cream-wielding usherette and his grandfather a brass-buttoned commissionaire. Consequently, he didn't have to pay to see a film until he was 21, and having to fork out for admission still comes as a mild shock to this day. After many years soaking up anything and everything on-screen he started to exercise a more critical eye in the 1980s, became obsessed with David Lynch movies and grew a goatee beard to give him something to stroke when patronising art house cinemas. The rest is cinematography. In his spare time he is the Arts and Social Sciences & Law Faculty Librarian at University of Bristol.

**DEIRDRE DEVERS** is a digital strategist and academic with an interest in screen cultures (e.g. online multiplayer gaming, cinema outside the multiplex), interactive entertainment and celebrity studies. When she's not reading about film, watching a film or wondering what film to watch next, she's probably shooting zombies on her Playstation and thinking about the influence of George Romero and David Lynch on converging entertainment forms. She also enjoys using film as a vehicle to spur young people's creativity whilst helping them to engage with film history, storytelling and technology.

**MICHAEL S DUFFY** teaches film and media studies in the Electronic Media and Film Department at Towson University in Maryland. His research interests are concerned with the aesthetics of cinematic visual effects and historicizing the transition from practical to digital techniques in special/visual effects. His Ph.D. concentrated on the acquisition and development of digital technologies in Australia and New Zealand's visual effects industries during

# CONTRIBUTORS

*Editor and contributing writer biographies (continued)*

the 1990s, and how changes in technology and approach influenced aesthetic shifts in filmmaking. Recently, he has contributed numerous essays to both the print and online versions of Intellect's Directory of World Cinema: American Hollywood volume, and a chapter on the television series Smallville for a book focusing on the show. He is currently preparing two books: an edited collection with Bob Rehak and Dan North on the histories and theories of visual effects, and a monograph focusing on how the film and media industries utilize stars' posthumous performances.

**SCOTT JORDAN HARRIS** is the editor of *The Big Picture* magazine. He writes for *The Spectator* and co-edits its arts blog, and is a contributor to many magazines, websites and journals, including *Film International*, *Fangoria* and *Rugby World*. He has also written for several books on cinema, including the London, Dublin and LA volumes of the *World Film Locations* series. His blog, *A Petrified Fountain*, was named one of the world's twelve best movie blogs by RunningInHeels.co.uk and can be viewed at www.apetrifiedfountain.blogspot.com.

**WAEL KHAIRY** is an Egyptian film critic writing for *C Mag*, Egypt's first English language magazine dedicated entirely to film. He is also one of Roger Ebert's Far Flung Correspondents and was named by the legendary film critic as a contributor to the golden age of film criticism in a *Wall Street Journal* article. Besides his website, *www.cinephilefix.wordpress.com*, and the *Chicago Sun-Times* blog, Wael also regularly writes for *The Spectator*'s arts blog. His passion for cinema started at a very young age when the viewing of *Jaws* triggered a movie-watching frenzy, and he has been reading about film ever since. Wael graduated from the American University in Cairo with a major degree in Communication of Media Arts, a minor in Business Administration and another minor in Film, which he completed at UCLA.

**TOBY KING** worked in an independent video/DVD rental store whilst he studied Film Studies and English at the University of Greenwich, London. He currently works for City Screen/Picturehouse Cinemas in Online Marketing, and as front of house staff at Britain's oldest cinema, The Duke of York's Picturehouse in Brighton. He has previously worked for Optimum Releasing and Future Shorts/Secret Cinema/Future Cinema in distribution and event planning. He writes film articles for *Don't Panic Online* (*www.dontpaniconline.com*) and *Spindle Magazine* (*www.spindlemagazine.com*). He blogs for *Picturehouse Cinemas* (*www.picturehouseblog.co.uk*), *Vice Blogging Network* (*VBN*) (www.viceland.com/uk/vbn) and his own film related blog, *Shine A Light* (*filmtobez.blogspot.com*).

**NEIL MITCHELL** is a freelance film critic, writer and editor based in Brighton, East Sussex. He graduated as a mature student from the University of Brighton with a BA in Visual Culture. Having contributed to various editions of Intellect's *Directory of World Cinema* series, he has taken on the role of co-editor for the British volume. His interest in all aspects of cinema has led to a growing fascination with British cinema in particular, which led to him editing the London volume of the *World Film Locations* series. He writes regularly for *The Big Picture* magazine, *The Spectator*'s arts blog and *RogueCinema.com*, and occasionally for VariedCelluloid.net and *Electric Sheep*. He can be found most days tweeting about film and other cultural matters on @nrm1972.

**MICHAEL PIGOTT** teaches film studies at the University of Warwick. He has written book chapters and journal articles on Japanese cinema, time and memory in film, new media aesthetics and East European cinema. He has work forthcoming on the relationship between video games and cinema and his current research focuses on video art and audio-visual culture.

126 **World Film Locations** | *Los Angeles*

**Isis Sadek** works as an Assistant Professor at the University of South Carolina. She is particularly interested in the relations between place, spatial practices, cultural identity and power in film and literature, with a special focus on Brazil and Argentina from the 1950s onward. She has published an article in the Intellect journal *Studies in Hispanic Cinemas* (volume 7, issue 1), tracing connections between space, affect and migration in contemporary Brazilian cinema, and showing how they redefine the north-east's arid landscape. Another forthcoming article deals with Argentine documentary cinema from the 1950s, linking the documentary gaze on marginal spaces to other contemporary modes of production of knowledge about 'under-development'. Los Angeles, both real and imagined, is one of the places that captures her imagination.

**Jesse Schlotterbeck** recently completed his Ph.D. in Film Studies at the University of Iowa. His dissertation is a critical history of the popular musical biopic from the 1960s to the present. Jesse's work also appears in *M/C – A Journal of Media and Culture*, the *Journal of Popular Film and Television*, *Scope: An Online Journal of Film and Television Studies*, the *Encyclopaedia of Documentary Film* and the *Journal of Adaptation in Film and Performance*.

**Andrew Spicer** is Reader in Cultural History in the Department of Art and Design, University of the West of England. He has published widely on film noir, including *Film Noir* (Longmans, 2002), *European Film Noir* (Manchester University Press, 2007) and the *Historical Dictionary of Film Noir* (Scarecrow Press, 2010). He is co-editing the *Companion to Film Noir* (Wiley-Blackwell, forthcoming, 2012).

**Benjamin Wiggins** is a Ph.D. Candidate in the Department of American Studies at the University of Minnesota. His dissertation investigates the role actuarial science plays in the construction and maintenance of racial categories and racism.

Benjamin has an article analyzing the imaginative geographies of South Central Los Angeles forthcoming in a Hofstra University Press volume on cultural representations of suburbia, as well as an essay on *Story of a Three-day Pass* set to appear in *World Film Locations: Paris*. He has taught courses on the politics of writing and on popular culture and politics in the twentieth century. He enjoys instant photography, cross-country skiing, cooking and watches baseball obsessively.

**Victoria Williams** was awarded her Ph.D. (King's College London) in 2008 for a thesis focusing on fairy tale in nineteenth-century literature and art and on film. Her film research focuses on the female Gothic film, cinematic fairy tales, representations of children, the works of Alfred Hitchcock and Hollywood during the Studio Era. She has given papers on *Beauty and the Beast* on film and the representation of childhood imagination in *The Curse of the Cat People* (von Fritsch and Wise, 1944). More recently she has written multiple entries for an encyclopaedia of American film and is currently writing about Ingrid Bergman's female Gothic films and the use of the *Bluebeard* fairy tale in the female Gothic neo-Victorian films of the 1940s and 1950s.

**Martin Zeller-Jacques** is an academic and freelance commentator on film and television, based at the Department of Theatre, Film and Television at the University of York, where he teaches a variety of courses to undergraduates and adult learners. In addition, he helps to organise the Beverley Film Society and has recently curated a screening series on the subject of film and authorship at the City Screen Cinema in York. He specialises in contemporary television narrative and has published academic essays on this subject, as well as gender theory and adaptation theory. He has also contributed reviews and articles to the *Directory of World Cinema* series and *The Big Picture* magazine online, and writes a regular blog about family life in a hyper-mediated world: *mediatedfamilyliving.blogspot.com*.

# FILMOGRAPHY

*A comprehensive list of all films mentioned or featured*